London

PHOTOGRAPHED BY MARK CHILVERS

It's almost 11am and the sound of horses' hooves echoes down The Mall. The horses are each wearing a breastplate and carrying a soldier dressed in a red tunic with a white-plumed helmet: they're the Queen's Life Guards and this is the daily Changing of the Queen's Life Guards, one of London's most famous (and photographed) ceremonies. You'll find some photos of the Life Guards among these pages but this is a book about so much more than a tourism tick-list of the British capital's highlights.

Our goal was to chronicle a day in the life of this great city from the perspective of a photographer who knows and loves it. We wanted to present not just the famous sights but also London's daily rhythms as a local would experience them. The book is loosely organised according to the passage of a day and night in the city: we start with a brave early-morning swim in the Serpentine lake of Hyde Park and finish with a night of live music and dance in south London. Along the way we follow the photographer on his peregrinations through London's diverse neighbourhoods, exploring their signature experiences, from tailoring and high finance to famed food markets, hidden gardens, local pubs and London's great galleries and museums. It would be impossible to capture all of London's incomparable variety but readers will discover a side to London beyond the famous sights.

For a task of this scale, we sought a photographer for whom London was not just home, but a source of inspiration. Mark Chilvers – who lives in Camberwell, south London – took his first portrait at the age of six and it was the start of a journey that led to him becoming a staff photographer at the Independent newspaper (then based in Canary Wharf). 'For me,' says Mark, 'photography is a way of slowing down to observe the world around me, while also asking myself to make creative sense of the city's chaos.' Helping Mark make sense of London was caption-writer Joe Bindloss, a Lonely Planet writer and editor whose first taste of London was a childhood living on the Caledonian Road. As well as writing about London, Joe has written for more than 50 guidebooks to Asia, Europe, Africa and Australia but between overseas hops he can often be found close to home in the ocakbaşı (Turkish grill houses) of northeast London.

Between them, they photographed and described all these facets of London life. The result is this chronologically-ordered visual odyssey through one of the world's great cities, a taste of London that may give first-time visitors fresh ideas of what to see and do, and also inspire long-time lovers of London to make another trip to The Big Smoke.

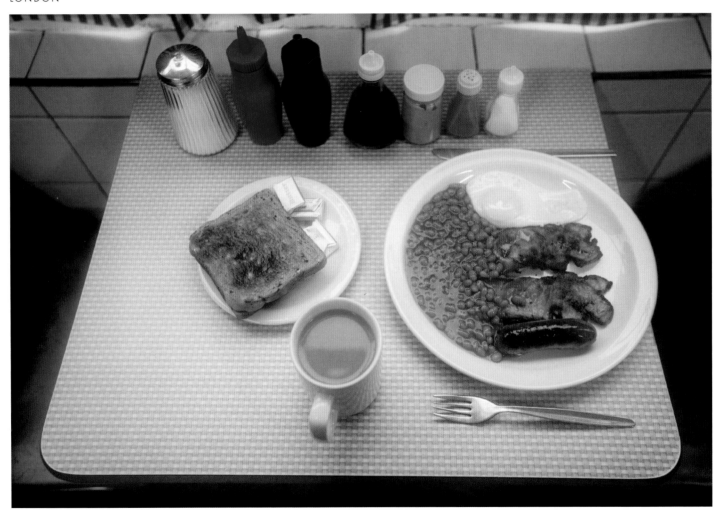

The origins of the 'full English' – sausage, eggs, beans, bacon, toast and tea – are lost in time, but its reputation as the chosen breakfast of the working classes is a relatively new development. Before the 17th century, treats such as bacon and sausage were the preserve of the wealthy upper classes.

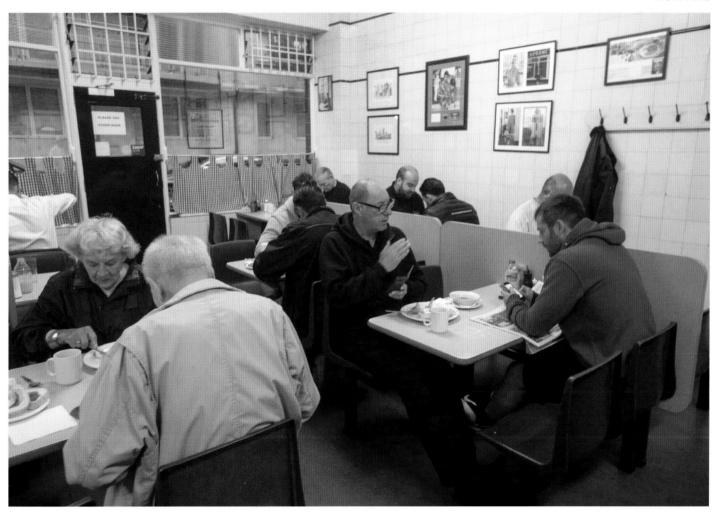

London's working-class cafes do a lively trade in hearty breakfasts for pensioners, who come to socialise and recapture the nostalgic simplicity of days past. The term 'greasy spoon' became mainstream in London during the 1950s, imported by soldiers who served with American GIs on the battlefields of Europe.

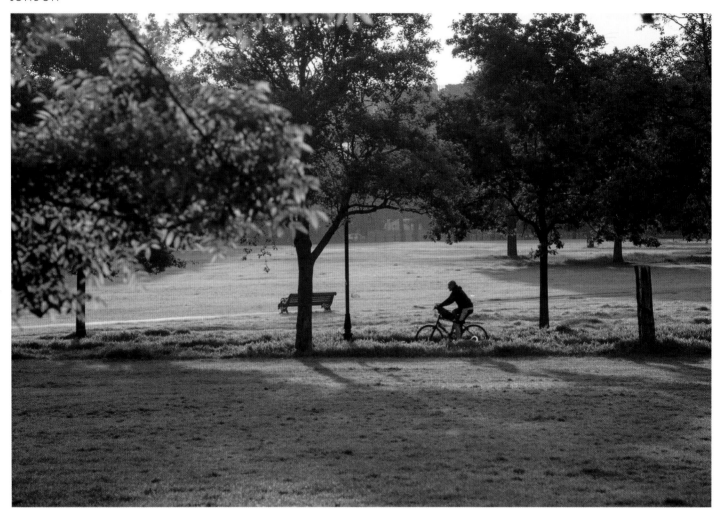

Green and pleasant Clapham Common was originally well outside London's metropolitan sprawl. The first house on the Common was built by parliamentarian William Hewer; the diarist Samuel Pepys died here as a houseguest in 1703, having come to 'paradisical Clapham' to convalesce in the healthy fresh air.

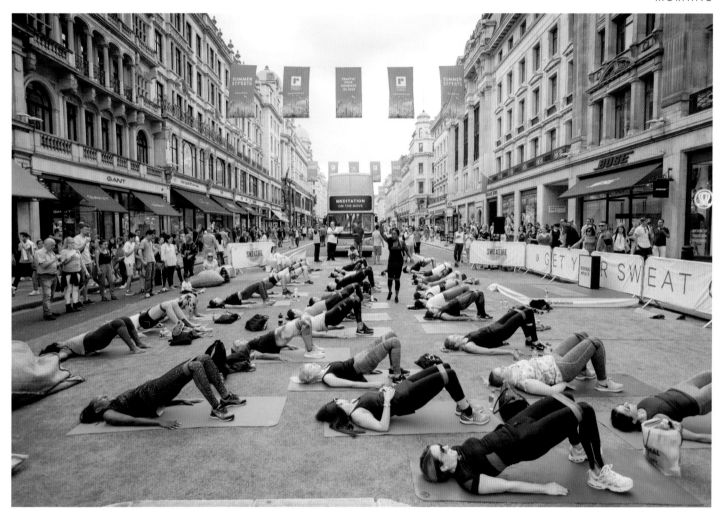

The sweeping curve of Regent St was designed by Sir John Nash in 1825 as a picturesque promenade for the Prince Regent, who lived at nearby Carlton House. Its appearance is little changed, though Quadrant Colonnades was demolished in 1848 because shopkeepers were outraged by the preponderance of prostitutes.

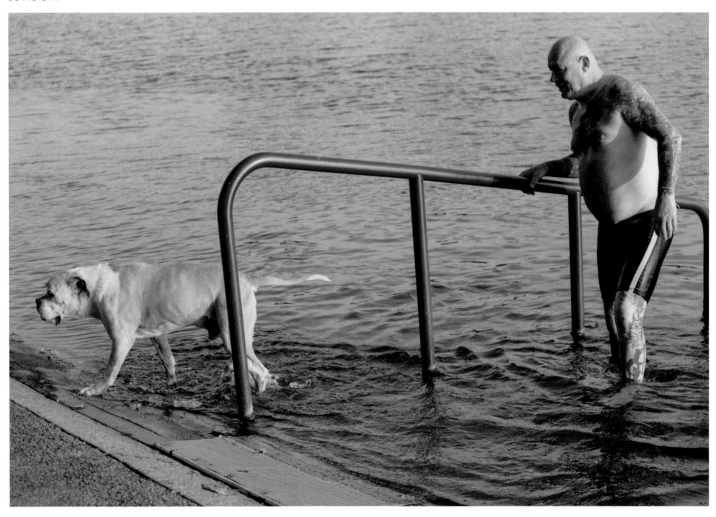

Swimming in the Serpentine is a London institution, and has been since 1730 when Queen Caroline, wife of George II, snipped a loop of the River Westbourne to create the ornamental lake in Hyde Park. Early patrons used to combine a visit with a trip to the public executions at Tyburn, near the modern-day site of Marble Arch.

'As I arrived at the Serpentine the sun was gently rising and a slow but steady gathering of early morning swimmers walked from the Victorian changing rooms to join the swans and ducks for their morning dip. The swans seemed more than happy to share their lake with the men and women of the Serpentine Swimming Club, and one man who came early to take his arthritic dog for a swim told me that it was almost too warm at this time in late summer.'

- Mark Chilvers

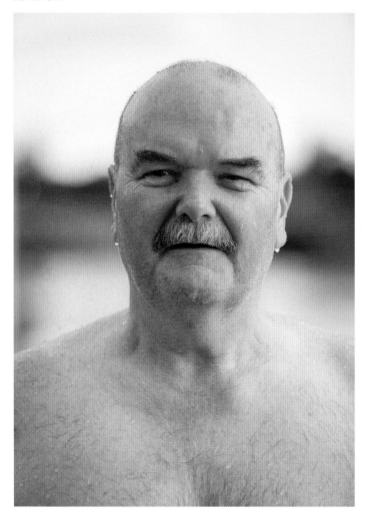

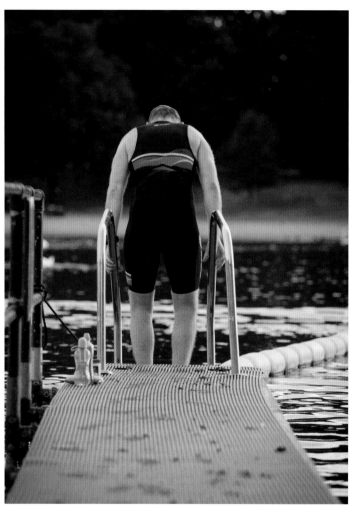

The Londoners who swim here span the socio-economic and cultural spectrum: black-cab drivers, retired shopkeepers, diplomats, famous Channel swimmers.

Nostalgia is part of the Serpentine Swimming Club's appeal – it is one of the last swimming clubs to still measure races in Imperial yards and inches.

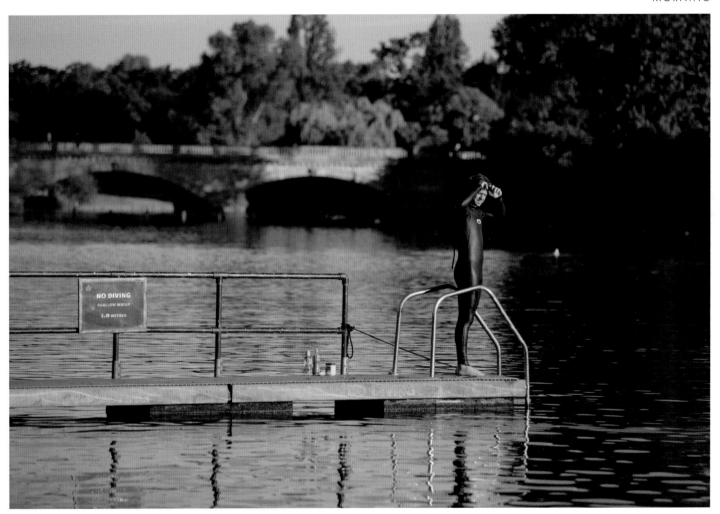

0800: Swimming in the Serpentine is not an activity to be taken lightly. The water temperature only climbs above 15°C (59°F) for a few months in summer, and swimmers who brave the cold waters without a wetsuit tow a dayglo float in case of sudden cramps.

Compared with London's other swimming ponds, the allure of the Serpentine has always been distance, 361ft (110m) shared only with fellow swimmers and the odd swan, goose or duck. It was the setting for the marathon swimming and triathlon events during the 2012 Olympics.

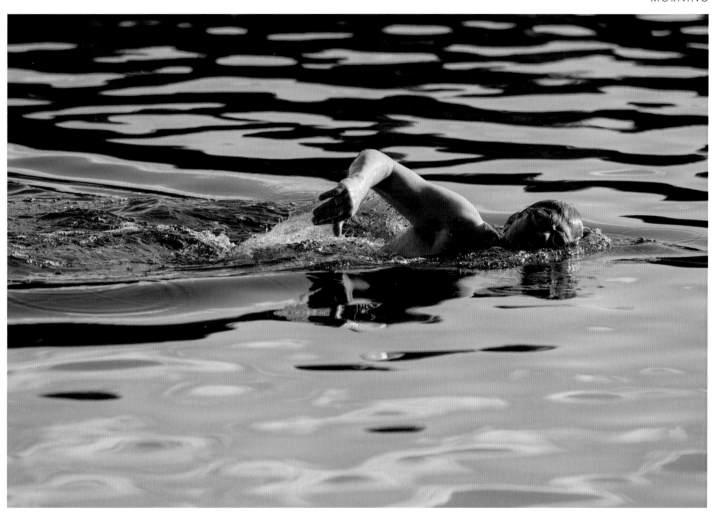

Since Christmas Day 1864, members of the Serpentine Swimming Club have been braving the icy waters for the Peter Pan Cup, named for author JM Barrie, who presented the winners' cup for nearly 30 years. The lake was one of the magical haunts of Peter Pan, now celebrated as a statue on the Kensington Gardens bank.

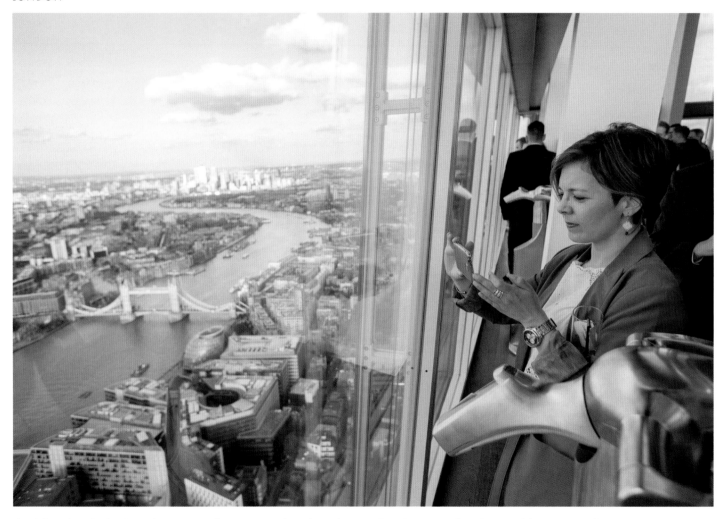

The skyline of London has been shooting upwards since 1669, when Christopher Wren forged a new city from the ruins of the Great Fire of London, starting with St Paul's Cathedral (see p18). In 2012, the Shard became the UK's tallest building at 1017ft (309.7m), though it only just scrapes into the world's 100 tallest buildings.

The observatory on the 72nd floor of the Shard is the highest in Britain, with the viewing deck at 802ft (244m) offering vistas as far as 40 miles (64km) out into the suburbs. On a clear day, the view takes in the Olympic Park at Stratford, the green bower of Hampstead Heath and planes taking off at City airport.

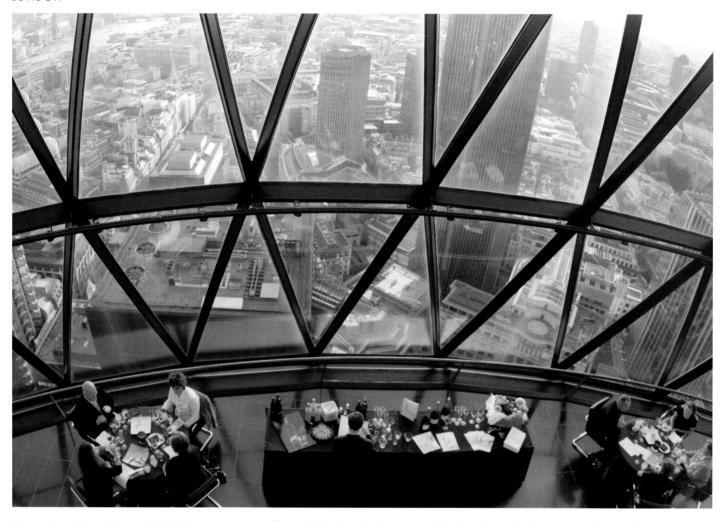

Norman Foster's iconic tower at 30 St Mary Axe was reputedly inspired by the natural structures of the Venus flower basket sponge, but to most this London landmark is simply 'the Gherkin'. Surprisingly, despite its curving form, all the panels of glass are actually flat, except for the bowl-shaped lens at the tower's apex.

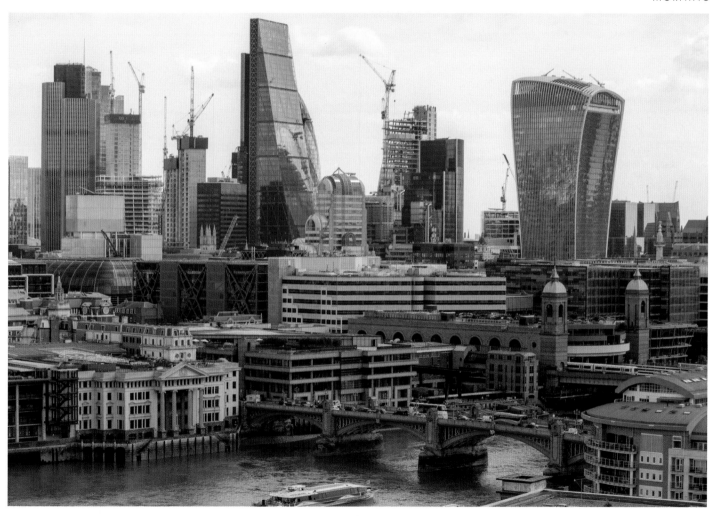

The skyline of London's financial district, known as the City or Square Mile, has been transformed in recent years and there are often as many cranes as buildings. Eye-catching – but by no means popular – postmodern structures include the Leadenhall Building ('the Cheesegrater') and 20 Fenchurch St ('the Walkie-Talkie').

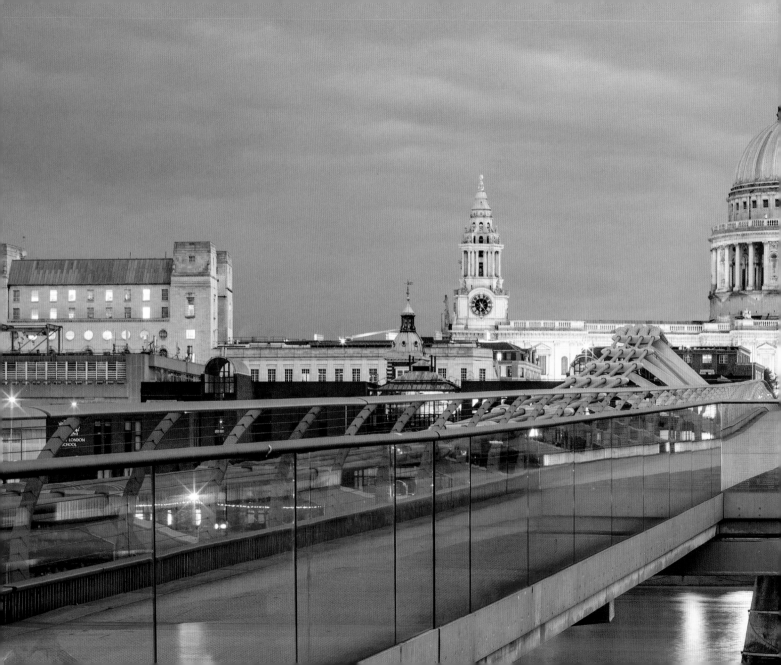

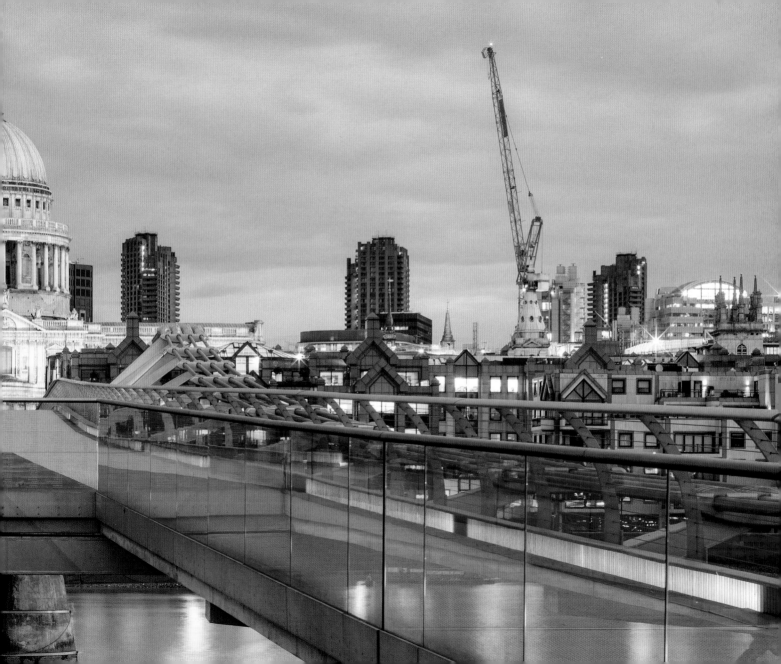

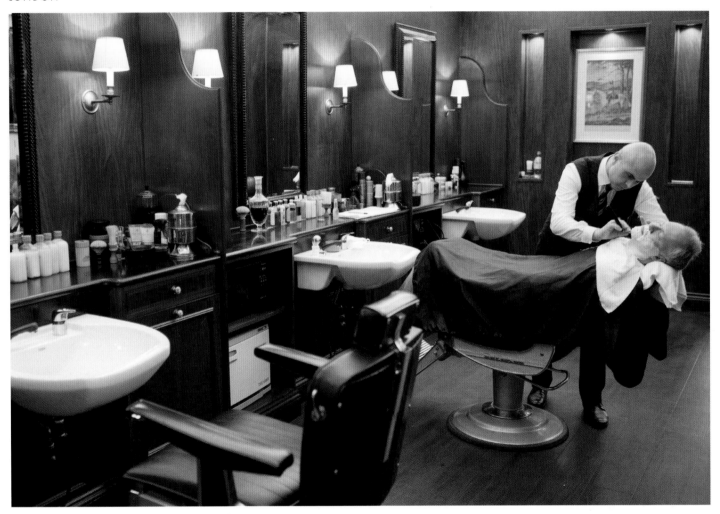

Until the invention of the safety razor in 1880, every shave in London was carried out with a straight razor, kept scalpel-sharp with a leather strop. London icon Truefitt & Hill of St James's is the world's oldest barbershop, with two centuries of experience of lather, bristles and warm towels opening the pores.

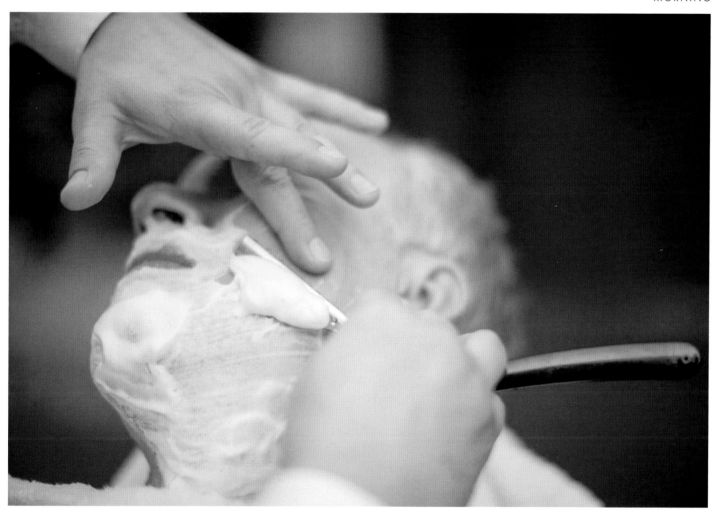

The traditional wet shave is enjoying a major revival in London with the fad for Victorian-style facial hair and masculine grooming. Aficionados insist that a proper wet shave should take a minimum of an hour, with lather applied with a badger-hair brush, finished off with a rub of astringent alum and a quality balm.

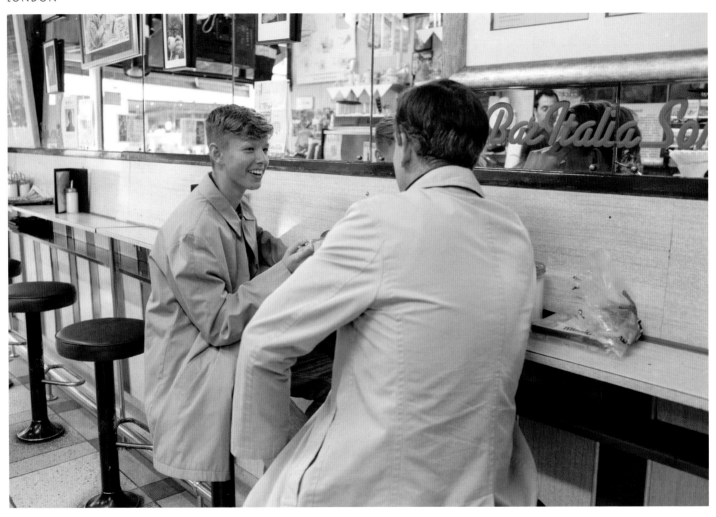

1000: In its day, Bar Italia in Soho – once London's nightlife hub – was where the bright young things of the Swinging Sixties gathered to gossip and sip on the newly discovered espresso. The Gaggia coffee machine has been in place ever since. Vespas out front likely belong to the Mod-inspired Bar Italia Scooter Club.

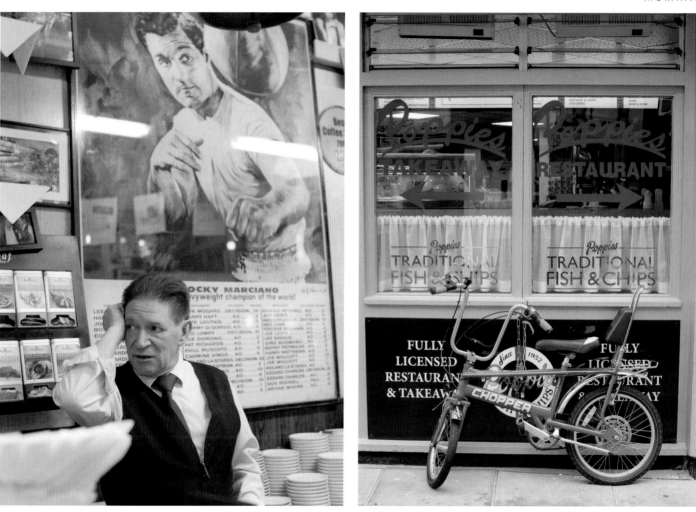

Despite the recent influx of film and TV post-production companies, Soho is famous for its stalwarts – characters such as Pat 'Pop' Newland, who has been frying up fish and chips at Poppie's since the age of 11, and Anthony Polledri, whose family has been steaming cappucinos at Bar Italia since 1949.

Eating pie and mash is fundamental to native Londoners, but the pies themselves have long been sold by traders from elsewhere. Generations of working-class locals have gathered at the pie shops run by the Manze family from Ravello, Italy, who started life as ice-cream makers before launching their pastry empire in 1891.

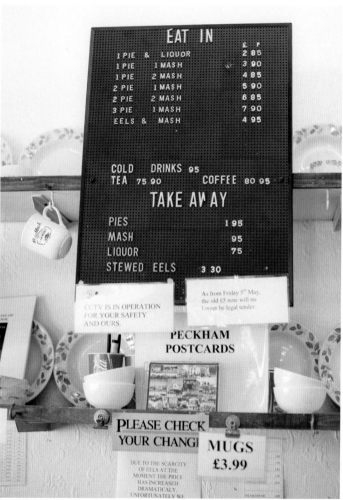

Served with a splodge of mash and a ladle of liquor – eel water, simmered with parsley – the meat pie has been a London staple for centuries.

Impoverished East Enders starting eating the freshwater eels that slithered abundantly through the murky waters of the Thames as long ago as the 1800s.

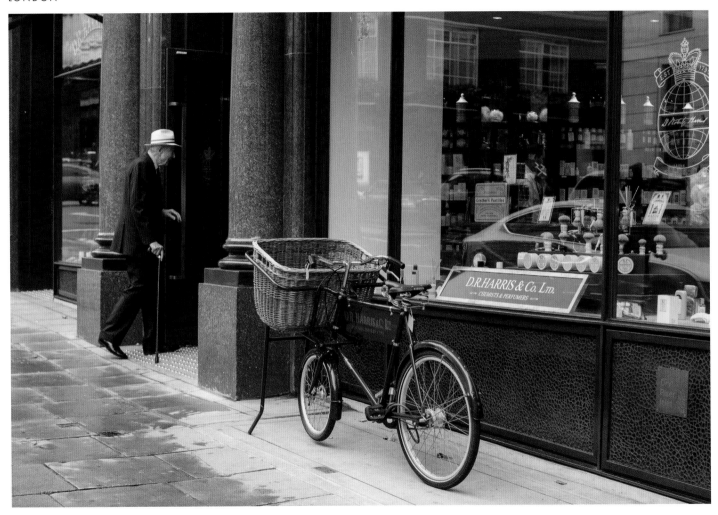

The streets of Mayfair and St James's are the last haunt of an endangered species, the old-fashioned London gentleman. This prim but flawlessly mannered character can be identified by his handmade shoes, tailored suit, palm-fibre Panama hat, wisps of snow-white hair, and animal-headed walking cane.

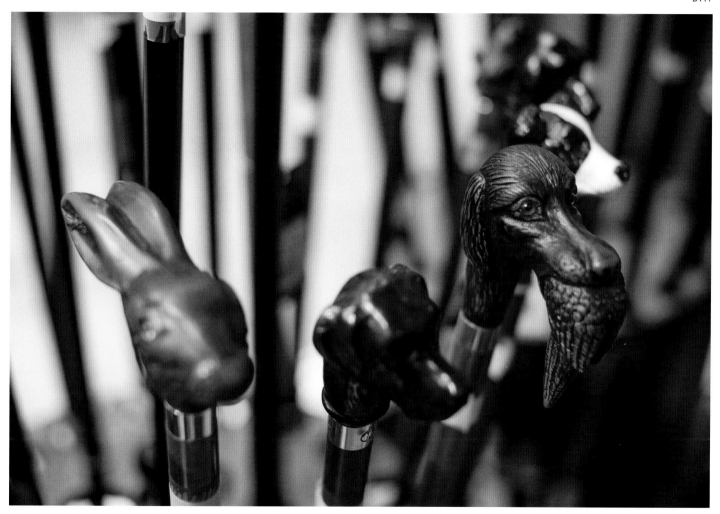

No well-dressed dandy would be seen dead without a walking stick, preferably topped with a carving of a game dog or a grinning skull. Until 1988, it was legal to carry a sword cane in London, but today the fashion is for lavishly priced designer canes from the likes of Alexander McQueen.

'When I arrived at John Lobb it was close to closing but I was welcomed in by William Lobb and the door was locked behind me. Walking downstairs was like walking into a subterranean world stuck somewhere in the last century. Craftsmen toiled over their workbenches hardly looking up from the individual job they were responsible for: last making, pattern cutting, stitching. I was shown a room where the wooden moulds of thousands of customers' feet fill every square inch from floor to ceiling. If a customer doesn't purchase a new pair of shoes for three years their last is taken to an off-site storage facility and kept for several more years before finally being disposed of.'

- Mark Chilvers

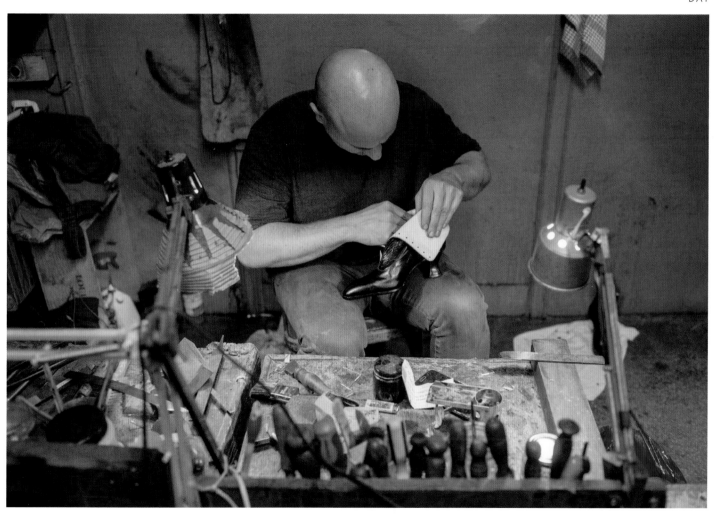

London prides itself on being at the forefront of fashion, and John Lobb Ltd has been at the vanguard of shoemaking innovation for five generations. Famous aficionados of the company's bespoke footwear include Winston Churchill, Roald Dahl, Frank Sinatra and Bollywood megastar Saif Ali Khan.

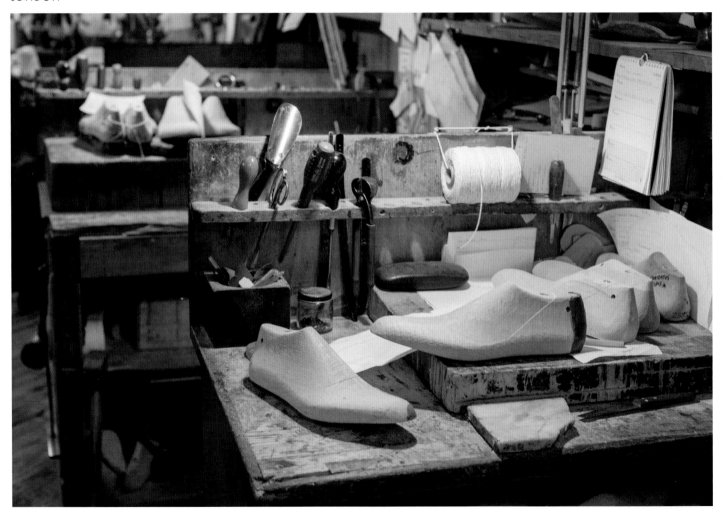

John Lobb's wooden lasts represent a who's who of well-heeled London. Each piece of maple, beech or hornbeam has been carved to the precise shape of a customer's foot, ensuring a precision fit. This craft and finesse commands a princely pricetag; a bespoke pair of John Lobb leather shoes is north of £4000.

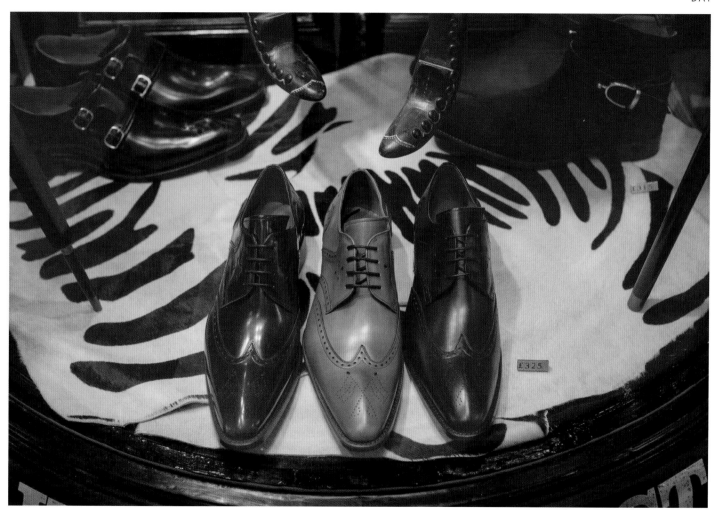

The shoe is the benchmark of sartorial elegance. To wear a custom-made leather shoe is to join an exclusive club, united by wealth and taste. With its decorated topcap, the brogue has been the shoe of choice for London gentlemen since the 1800s, but few recall its origins as wet-weather footwear for the working classes.

Lock & Co has the distinction of being the world's oldest hat-shop, founded in 1676, a full century before Beau Brummell put London on the fashion map. Among other innovations, Lock & Co commissioned the first Bowler (Coke) hat, designed to protect horseriding gamekeepers from low-hanging branches.

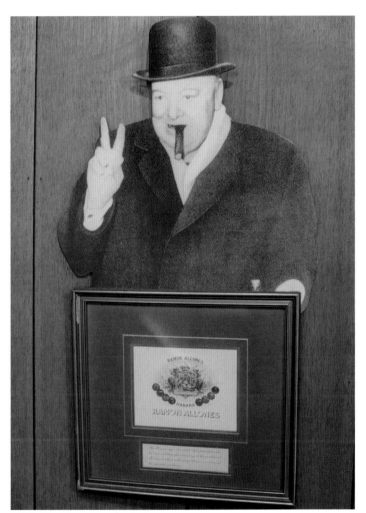

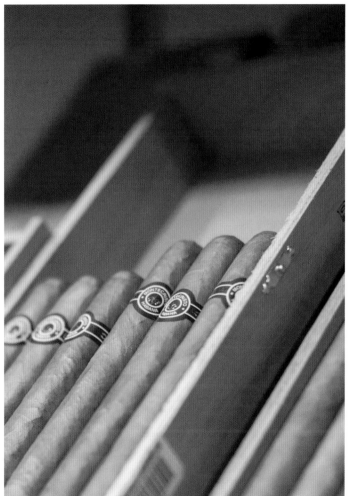

Dunhill Tobacco of London Ltd started life selling car accessories to London's motorists, but the invention of the 'windshield pipe' marked a shift to tobacco.

The Churchill – a 7in (18cm) Havana with a ring gauge of 47 – took off when Winston Churchill was elected prime minister for the first time in 1940.

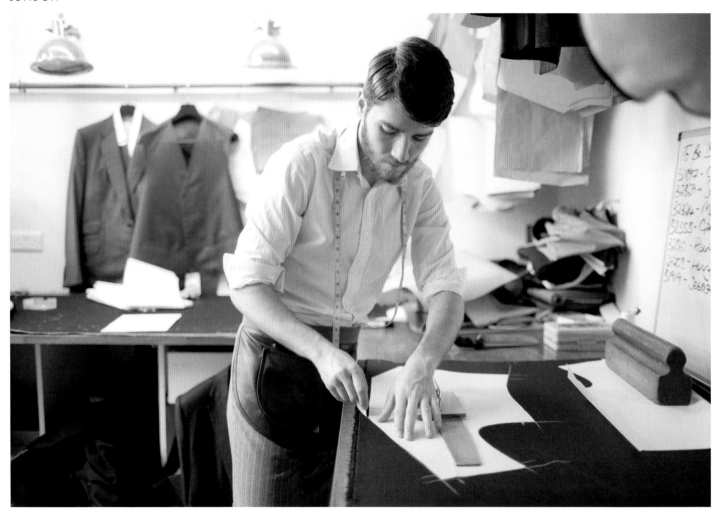

Regency fashion icon Beau Brummell was the original London dandy, pioneering, among other things, the necktie and full-length trousers. Cad & the Dandy, founded by two City bankers made redundant in 2008, continues the tradition on London's Savile Row, the most prestigious address for tailors since the 1730s.

The two-piece suit has been the benchmark of gentlemen's style since Beau Brummell's time, and is worn by the majority of the 200,000 men who flood into the City every day. The Gordon Gekko look of pinstripes and braces, however, is frowned on at the upper levels of finance as being only suitable for the trading floor.

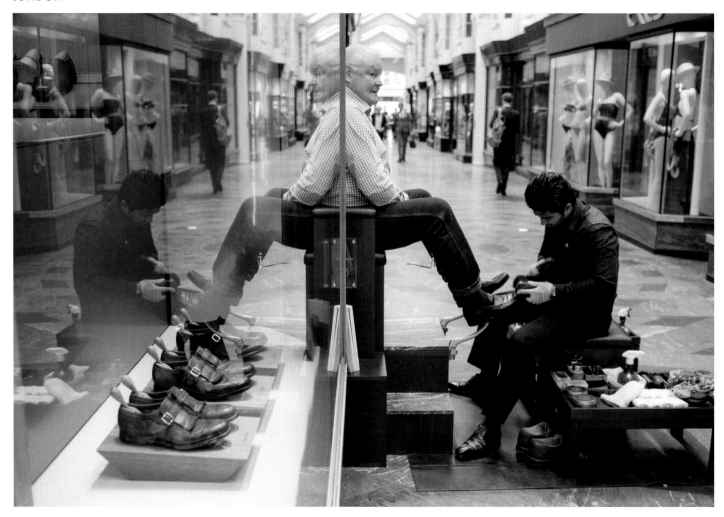

Once ubiquitous across London, the old-fashioned shoe shine is now restricted to upmarket precincts such as the Burlington Arcade. As in its heyday, shoeshining still brings Londoners together across social divides, as old-money aristocrats mingle with the latest generation of Londoners to arrive from across the globe.

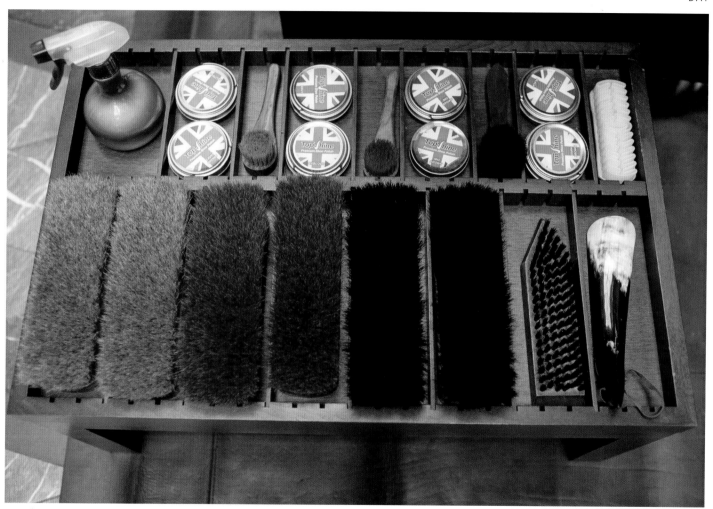

A proper shoe shine is a multilayered process. The first pass with a cleaning brush whips away dirt and dust, and a damp cloth primes the leather for shining. The polish is applied with a dauber, to prevent heavy build-up, before the leather is buffed to a rich sheen with a horse-hair brush colour-matched to the polish.

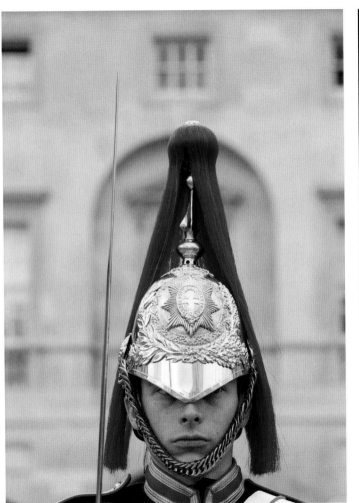
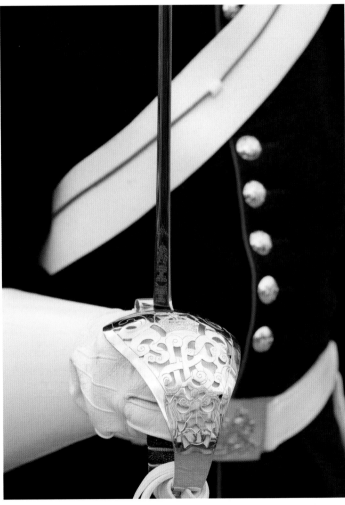

1100: Often assumed, incorrectly, to be purely ceremonial, the commonly snapped Household Cavalry are trained soldiers, charged with protecting the life of the British monarch. Behind the scenes, armoured personnel carriers back up the polearms and sabres of the mounted cavalry.

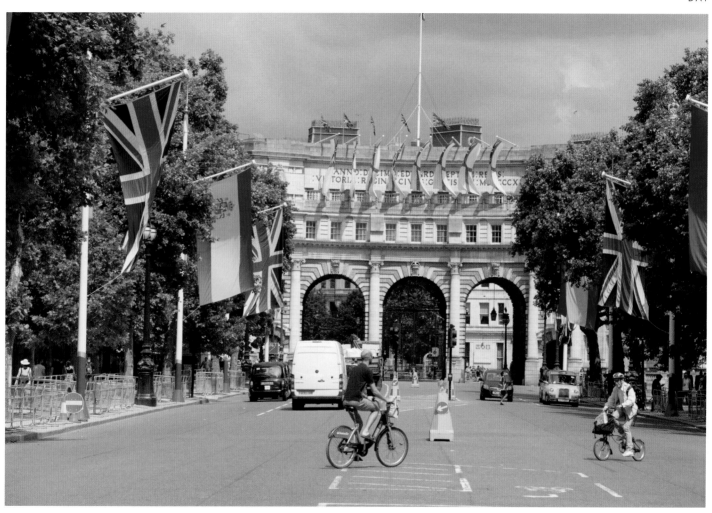

The Mall might qualify as the world's grandest front drive, linking Buckingham Palace to Trafalgar Square, and topped with iron-oxide tarmac to create the illusion of a red carpet. Now a popular promenade, it's still used for official functions, when the colours of visiting heads of state flutter flamboyantly from the flagpoles.

The soldiers stationed at Horse Guards are famously well-behaved, a necessity considering the constant poking by tourists, but the horses are another matter. The mounts of the Household Cavalry are selected for their martial posture, but get time off every July for an R&R break by the seaside in Norfolk.

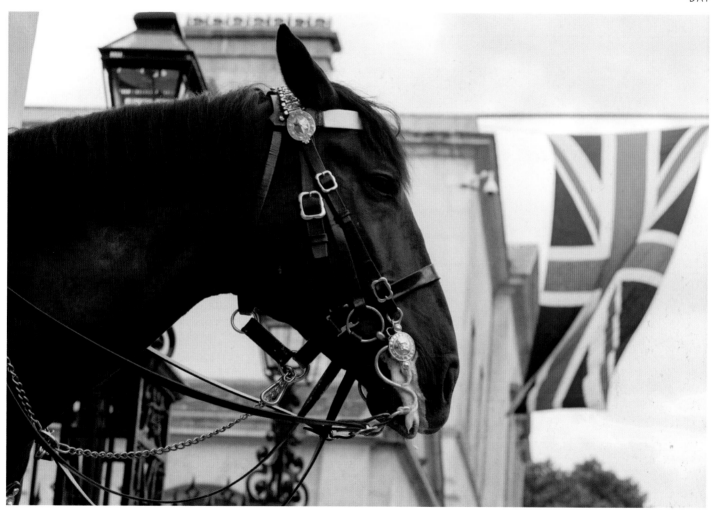

The changing of the Queen's Life Guard is one of London's most famous tourist spectacles, and a reminder of the pomp and circumstance accompanying royal functions. A second parade takes place daily at 4pm, allegedly imposed as a punishment after Queen Victoria caught the guardsmen drinking and gambling on duty.

Leadenhall Market has been pulling in London traders since the 14th century, but the present structure was a Victorian marvel of cast iron by Sir Horace Jones in 1881. As well as being a favourite haunt of City brokers, the market stood in as the entrance to Diagon Alley in the film *Harry Potter and the Philosopher's Stone*.

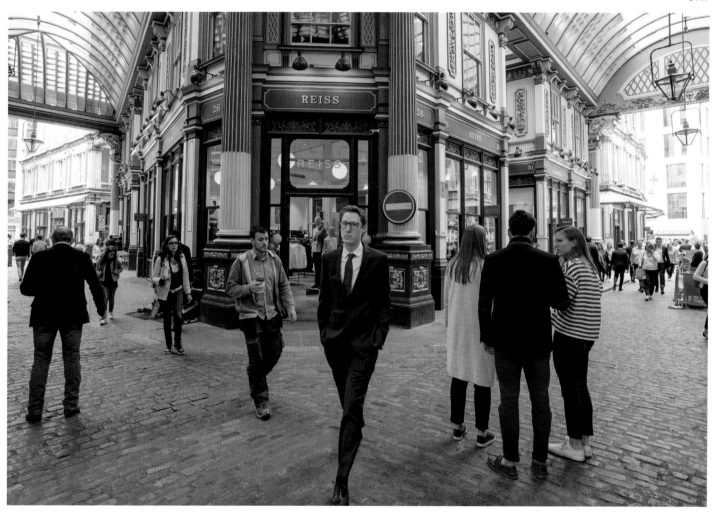

The land on which Leadenhall Market stands was gifted to the City of London by Lord Mayor Richard 'Dick' Whittington, later immortalised in pantomime. There is no evidence that he ever had a cat, but he made lavish gifts to the city, including building some of the first drains in deprived parts of London.

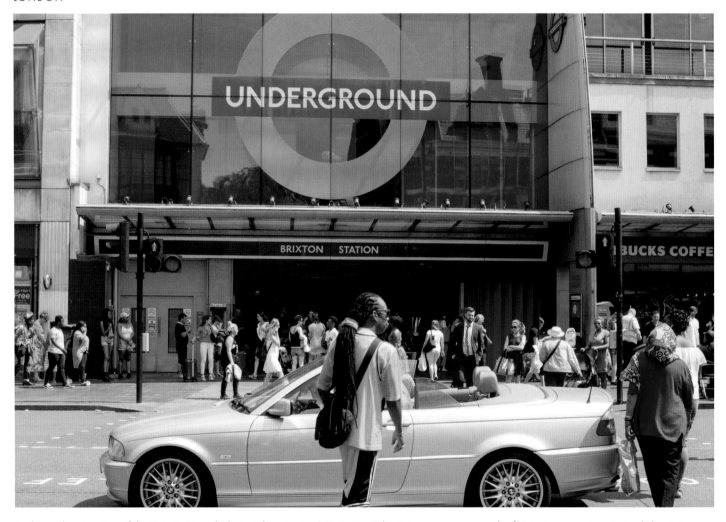

As the southern terminus of the Victoria Line, which started service in 1971, Brixton Tube station never saw crowds of Victorian commuters. Instead, the station grew as a vital hub for London's Caribbean population, who set up shop in Brixton after the arrival of the Empire Windrush from Jamaica in 1948.

Tube stations play a special part in London's psyche. Each has its own mood and character, though refurbs have robbed many of their original tilework and signage. Labyrinthine tunnels link the different Tube lines, including the 1395ft (425m) hike from Bank to Monument, London's most awkward interchange.

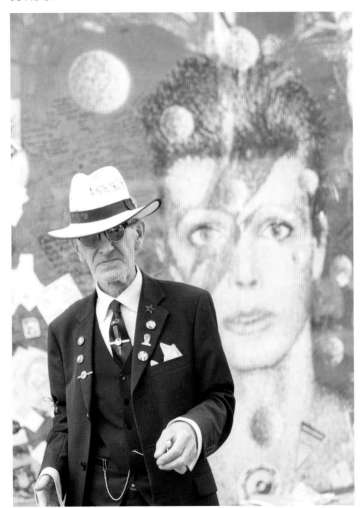

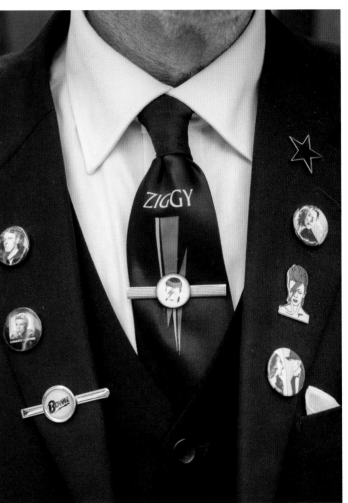

Ziggy Stardust mural by Jimmy. C (www.akajimmyc.com)

Brixton is famed as cultural melting pot, but its most famous son was a Londoner born-and-bred: David Robert Jones – aka David Bowie. He was born and grew up at 40 Stansfield Road, but is immortalised today by a mural on Brixton High Street, a shrine for fans like Clive Daly (pictured here) since Bowie's death in 2016.

'I met Clive Daly, bedecked in a fine suit and Panama hat, at the David Bowie memorial mural opposite Brixton Tube. He was playing a selection of his favourite Bowie songs on CD and told me he was keeping an almost daily vigil to commemorate his musical hero. A pile of used batteries littered the floor around his CD player and he made regular trips to the £1 shop around the corner for more supplies. When I went back recently to check on Clive he was nowhere to be seen; I was told that his stereo had been stolen while he was shopping for batteries, but that he was still maintaining his one-man vigil on Fridays and Saturdays.'

- *Mark Chilvers*

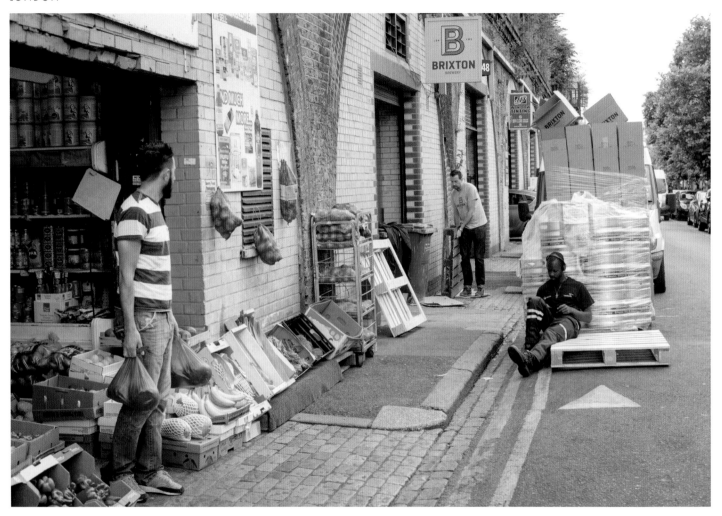

Brixton's journey from social deprivation to gentrification gathered pace in the Noughties, as premises once selling ackee and import vinyl from Jamaica turned into coffee shops and artisan bakeries. For some, the shift is the latest chapter in a story of changing communities; others mourn Brixton's vibrant West Indian past.

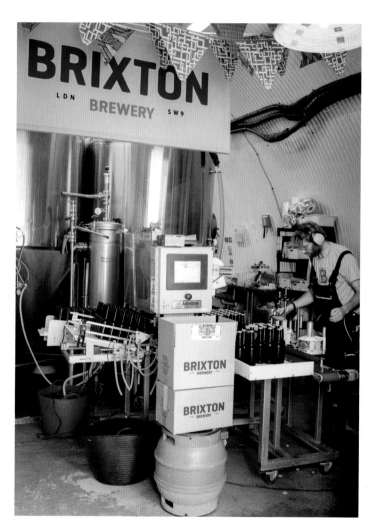

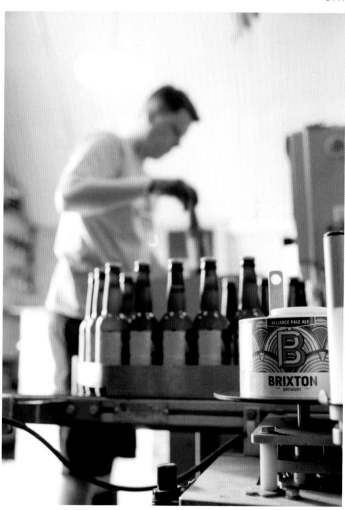

London has a rich brewing tradition, from earthy Fuller's ales to Truman's Brewery's much-missed porters, first brewed off Brick Lane in 1666.

Founded in 2010, Brixton Brewery is part of the new guard, brewing Indian and American pale ales and stout in railway arches.

Brixton Market has always been a barometer of its people: sometimes rough around the edges, but always gregarious, friendly and loud. The market still sells West Indian staples such as saltfish, yams and Haile Selassie paraphernalia, these days joined by hipster staples like world food condiments and vintage bric-a-brac.

Chip Shop Bxtn channels the spirit of old-skool US hip-hop with its spray art and DJ playlist, but America might never have embraced black music without the success of Eddy Grant's 'Electric Avenue', one of the first songs by a black artist to gain airtime on the hitherto monotone cable channel MTV.

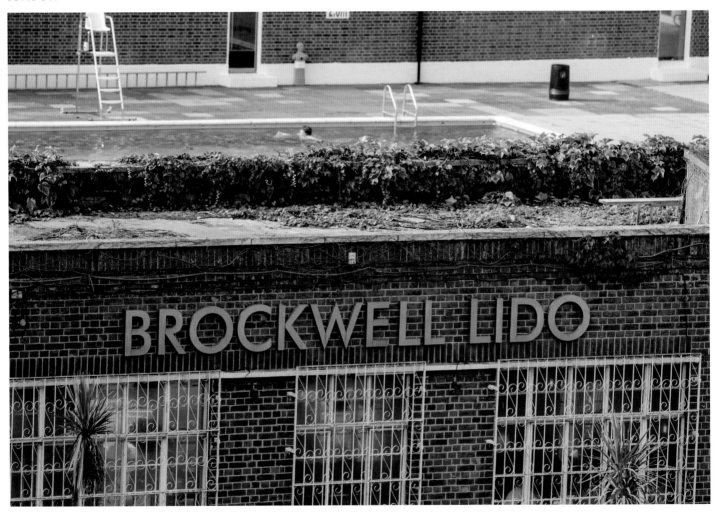

1200: Glamorously appropriating the Italian word for beach, London's first open-air lido opened at Edmonton in 1935, as London embraced the new concept of 'leisure' after the privations of WWI. Similar pools opened all over London, including at Brockwell, one of the capital's oldest functioning lidos.

'There's an interesting story about the founding of Brockwell Lido. In 1937 the pool was declared open when the then Mayor, EA Ellis JP, threw a schoolgirl named Thelma Phelps into the pool. On the lido's 80th anniversary, swimmers born in each of the intervening decades threw themselves into the unheated waters to celebrate this historic event.'

- *Mark Chilvers*

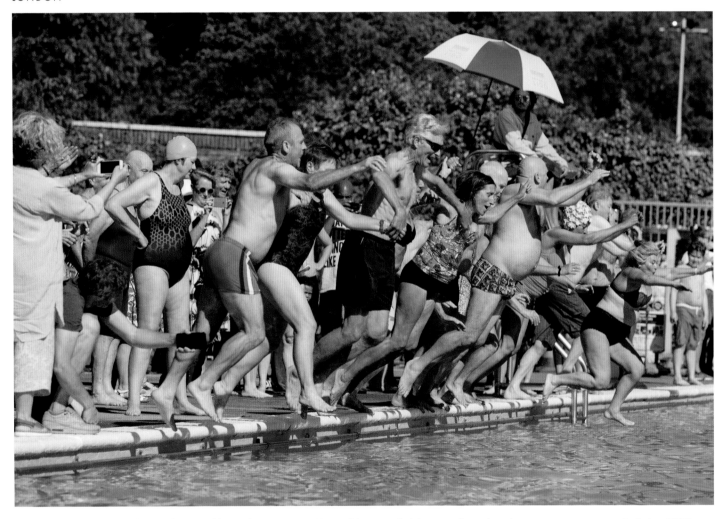

London might not seem an obvious playground for outdoor swimming. Many of the capital's lidos are unheated, and water temperatures can dip below 20°C (68°F) in winter. The Brockwell Swimmers brave the water year round, in wet suits, rash vests, boots and gloves during the icy winter months.

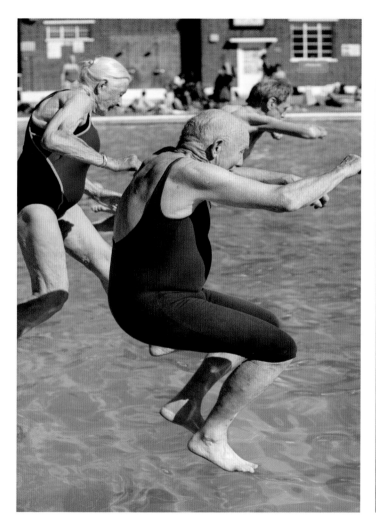

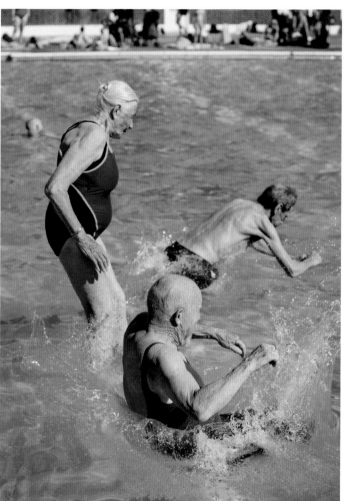

The arrival of Lidos in Britain coincided with that of the modern bathing suit; before WWI, swimwear was simply designed to protect modesty.

In 2017, Brockwell Lido celebrated its 80th anniversary, with bathers leaping into the water in generational waves, based on the decade they were born in.

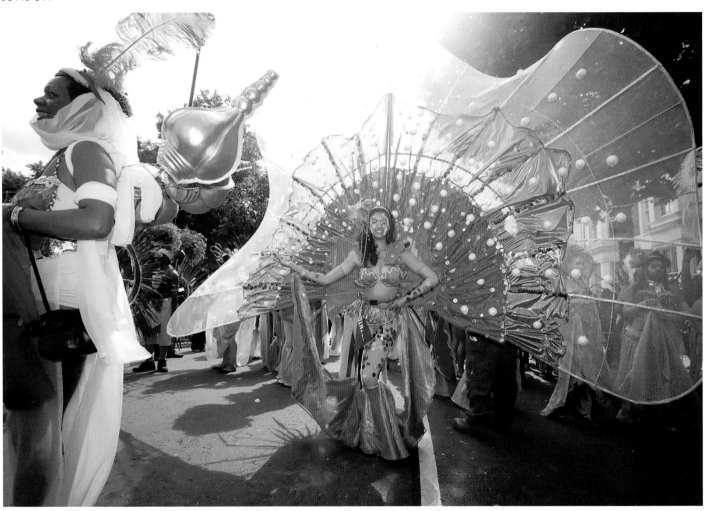

It's a reflection of London's diversity that Europe's biggest street festival, the Notting Hill Carnival, is also the largest festival of Caribbean culture outside the Caribbean, and the second-biggest carnival in the world after Rio. The 2017 celebrations drew more than a million people, over 80% of them London residents.

Today's costumed parades turn Londoners into peacocks and local schools into ambassadors for Caribbean culture, but the first carnival was a much more sedate affair. The 1959 Caribbean Carnival was held at St Pancras Town Hall, with dancing toned down for the cameras of the BBC.

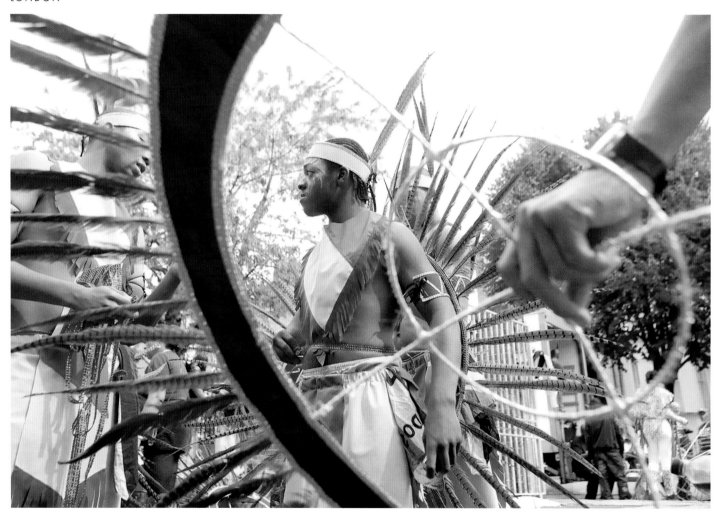

The costumes of Notting Hill's mas (masquerade) troupes are a riot of sequins, feathers and lamé, but it takes work to achieve this level of flamboyance. Mas troupes work year round on their costumes, using some 30 million sequins and more than 15,000 feather plumes every carnival.

Traditional West Indian steel bands fill the streets with tinkling rhythms, but these days carnival is dominated by sound systems – an idea imported from Jamaica, where teams of young MCs and DJs set up mobile nightclubs with booming speakers piled onto flatbed trucks as a way to make quick cash.

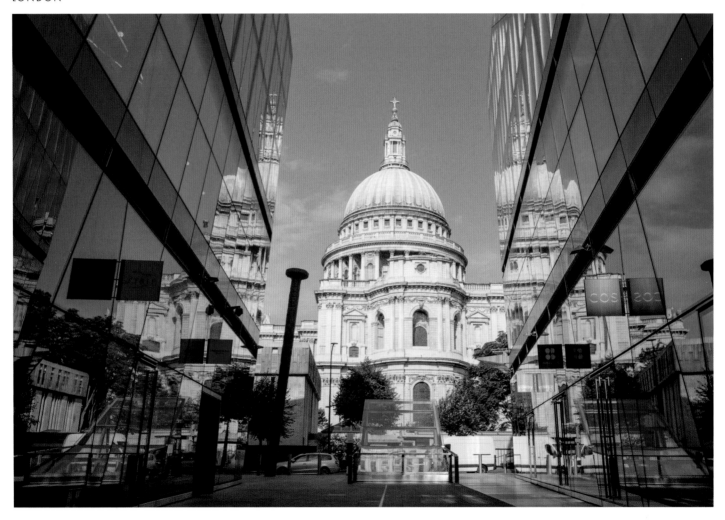

Sir Christopher Wren's plans for a new St Paul's Cathedral to replace the original lost in the Great Fire of 1666 were rejected several times as not being sufficiently grand for the City of London. It is still a functioning church, even holding weddings for members of the Cathedral community and select others.

The Bank of England may hold just a fraction of the wealth that it did in the days of the British Empire, but it still plays a pivotal role in the finances of the nation. Some 400,000 gold bars, worth upwards of £100 billion, are locked in its vaults, protected by an armour-plated door that can only be opened with 3ft-long (0.9m) keys.

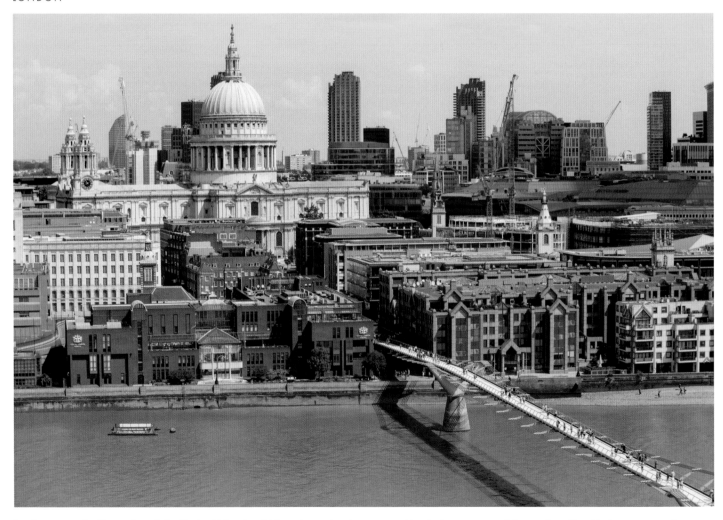

Leading across the Thames from St Paul's, the Millennium Bridge takes pedestrians to one of London's most successful attractions, Tate Modern, an art gallery repurposed from a power station in 2000. The gallery, which receives almost 6 million visitors annually, opened a vast extension by Herzog & de Meuron in 2016.

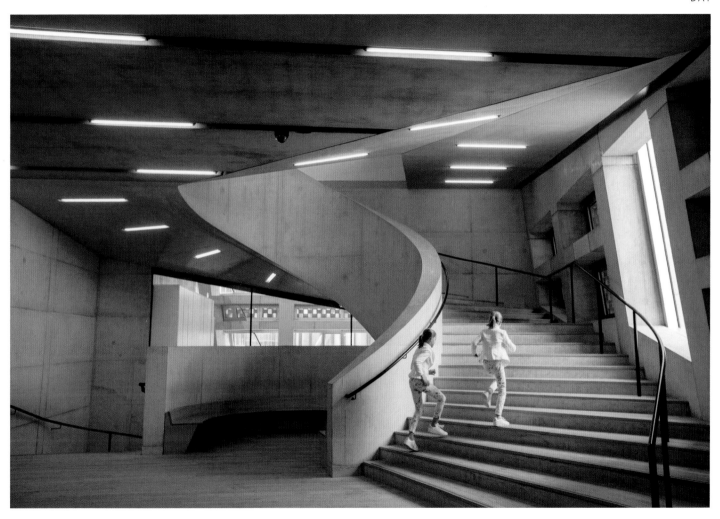

Before it closed in 1981, the plant at the former premises of the Bankside Power Station supplied most of the electricity to the City of London, burning fuel stored in three enormous storage tanks now remodelled as permanent performance art spaces for Tate Modern.

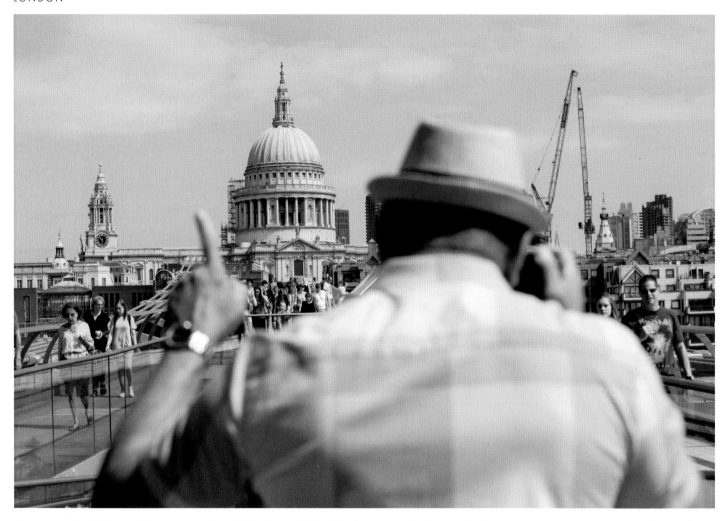

Once its initial wobbling problems were sorted out, the Millennium Bridge found its way into the hearts of Londoners, providing an easy connection between Tate Modern and St Paul's. The wobbling itself was caused by 'positive feedback resonance' – the swaying of pedestrians, which reinforced the bridge's oscillation.

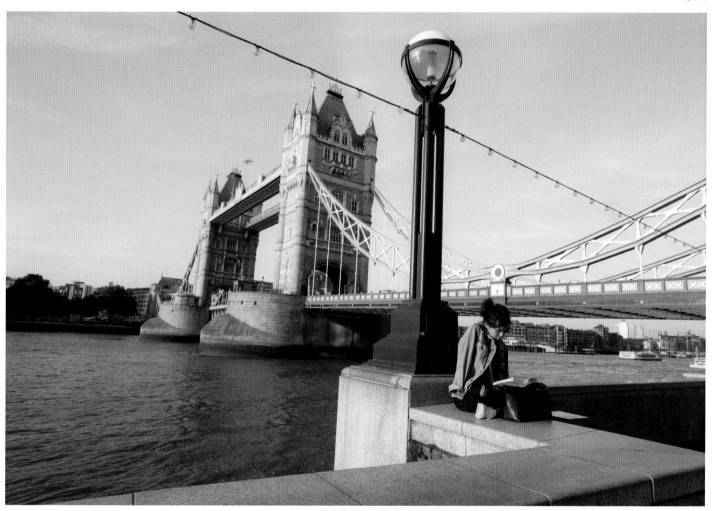

The bridge that American Robert P McCulloch supposedly thought he was buying when he paid US$2.46 million for 'London Bridge' has been a London icon since it opened in 1894. According to legend, the German Luftwaffe used Tower Bridge as a navigational aid, preserving it from the bombing raids of the Blitz.

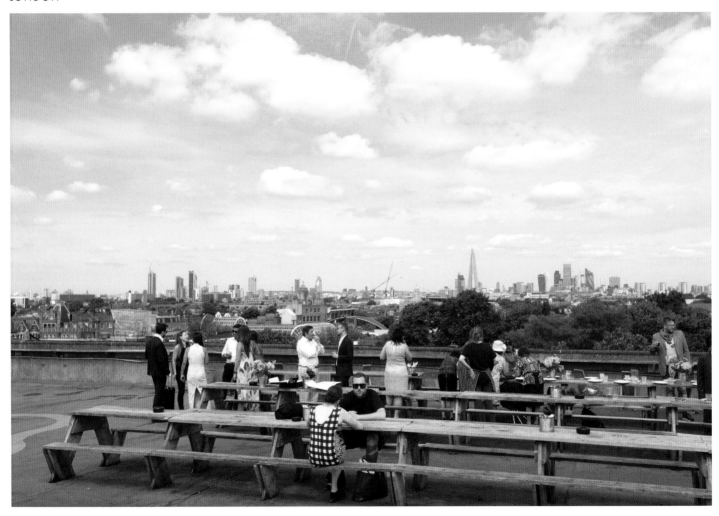

As the city continues its vertical expansion, so Londoners are making use of new manmade vantage points or ingeniously re-fashioning old ones. Frank's Cafe in Peckham is a bar and restaurant occupying a prime position on the 10th floor of a disused multistorey car park.

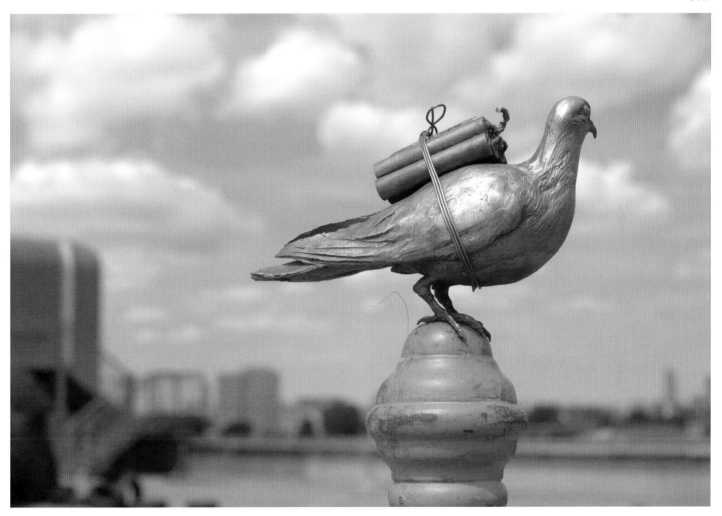

London has been pop-up obsessed ever since the movement gained traction in the early Noughties. Art space Bold Tendencies, which designed Frank's Cafe, has turned the former car park into a haven for Peckham creatives, who come for the design buzz and artworks such as Adel Abdessemed's bomb-totting carrier pigeon.

In a patch of Victorian East London that escaped the incendiary bombs of the Blitz, Columbia Road flower market has been famed for its blooms since 1869.

The market is popular with self-styled urban dandies – such as Flash Gordon the Mad Hatter – who make prolific use of the area's vintage clothing stores.

Bethnal Green's love for flowers is rooted in its history as a refuge for exiles. Flower-selling took off under the Huguenots – Protestants fleeing persecution in Catholic France – with the market later shifted to Sundays to accommodate the preferences of Jewish traders who followed, escaping pogroms in Eastern Europe.

Today, the flower market is one of London's most frenetically crowded public spaces, attracting everyone from Instagramming tourists to student film-makers and restaurateurs bulk-buying table-top posies. Shoppers toting trollies bursting with plants and bouquets fill the streets as the market ends on Sunday afternoon.

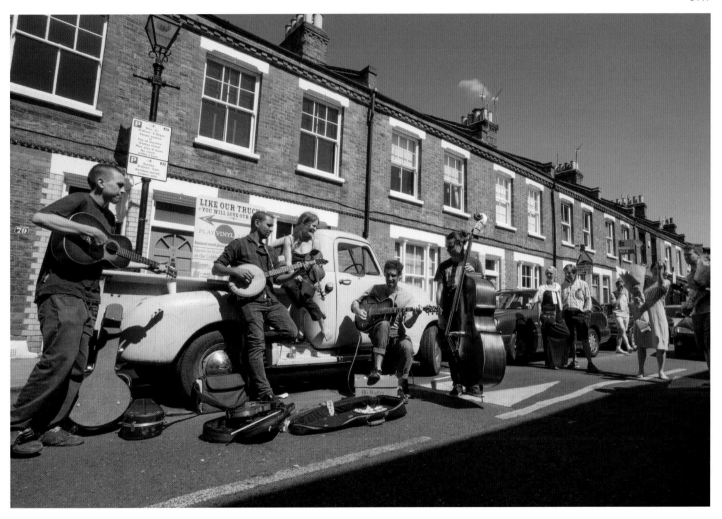

A bohemian music scene has grown up around market day, with buskers playing skiffle classics and Quintette du Hot Club de France-era tunes on weatherworn banjos and archtops. Regulars drift into the market's sidestreets with a fair-trade coffee or a punnet of tempura prawns to listen to the show.

'I discovered the Nomadic Community Gardens purely by chance. I stepped through a hole in a fence to find a collection of semi-permanent buildings covered in graffiti and street art and sculptures made from scavenged materials, with an almost steampunk aesthetic. As I entered this hidden shanty town, I saw artists spraying new work on the walls while a crowd watched from weather-worn sofas or drank beers at a pop-up bar. Hip hop blared from the speakers while men and women from the local Bangladeshi community tended allotments provided free of charge by the commune.'

- Mark Chilvers

As gentrification has gripped the East End, spaces formally occupied by struggling artists have fallen to offices and luxury flats. Against this corporate backdrop, the Nomadic Community Gardens hoist a flag for an alternative way of life, based on self-sufficiency, horticulture and community-based art.

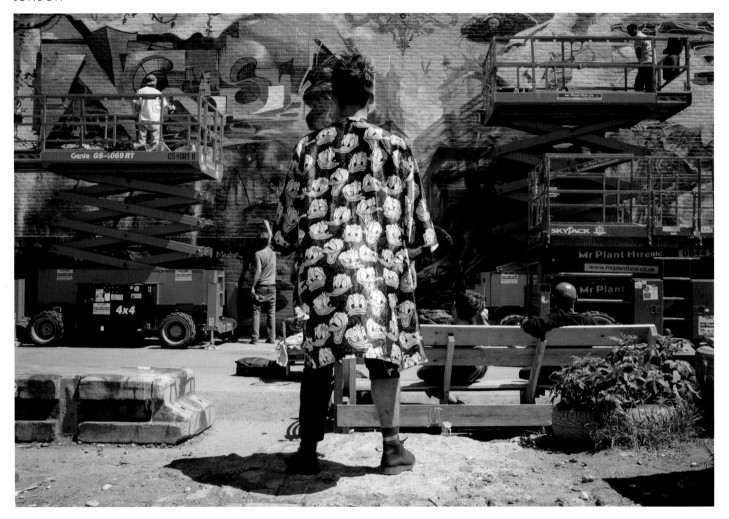

London's answer to Copenhagen's Freetown Christiania is part urban farm, part public art space, with a proud community conscience. Vegetables are raised in communal plots, some of which are offered for free to migrant families, while artists create sculptures from scrap, challenging the notion of neglect in the inner city.

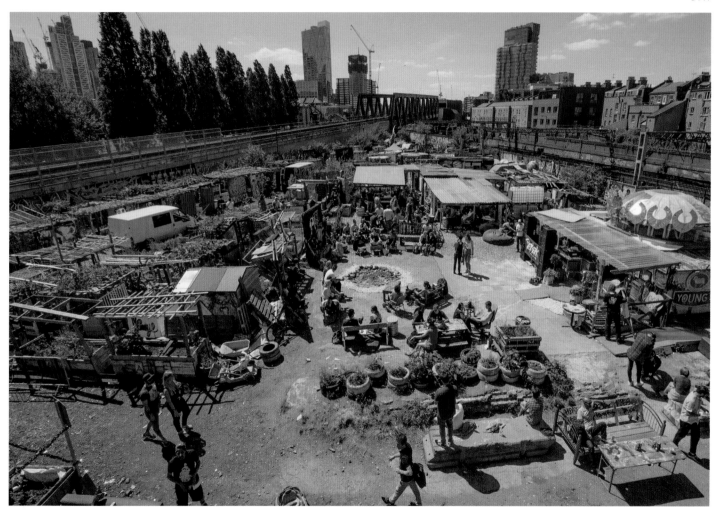

As real-estate values in London have surged skywards, thousands of once-public spaces have been consumed by developers' diggers. Informal community schemes such as the Nomadic Community Gardens and Dalston's Eastern Curve Garden cling on in patches of land formerly used for railway sidings and storage depots.

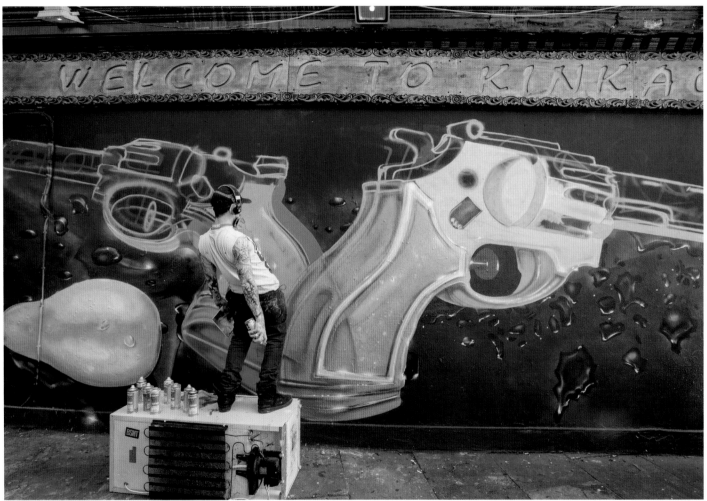

Artwork 'Water Violence Only' by Fanakapan

As in urban centres across the globe, London's fabulous wealth has only trickled down so far; large areas struggle with poverty, social deprivation and violence between street gangs. Fanakapan is one of a new generation of street artists using grafitti to protest against street violence, elevating the art to social commentary.

In Brick Lane, a different confrontation is taking place as Bengali clothing workshops are reinvented as cocktail bars and breakfast cereal cafes. Commentators alternate between celebrating the wealth bought to the area by gentrification, and condemning it for changing the East End's social fabric.

Trendy twentysomethings are now as ubiquitous in the once gritty side-streets off Brick Lane as the famed curry houses that line its southern half

With its vintage stores and indie-designer boutiques, Brick Lane has become a haunt for modern-day dandies who mix urban street style with reclaimed chic.

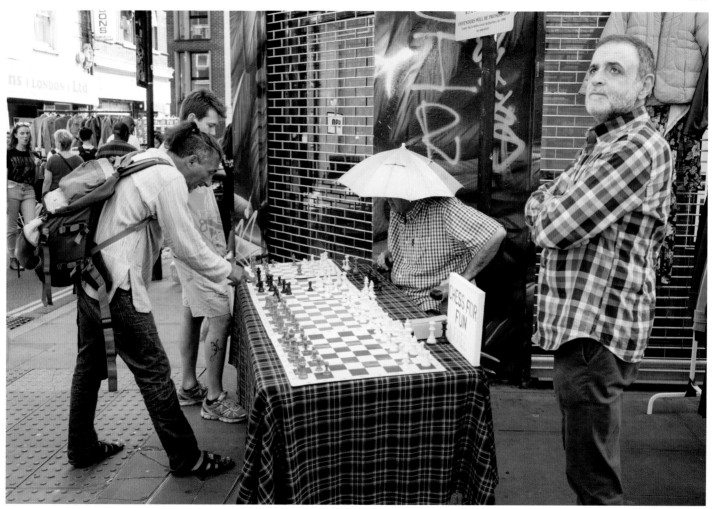

One thing most Londoners agree on is that the East End provides a haven for bonafide London character archetypes – such as the Brick Lane Chess Master, who challenges all-comers to spontaneous games of chess – flying the flag for a lifestyle based on unforced interaction, personal passions and eccentricity.

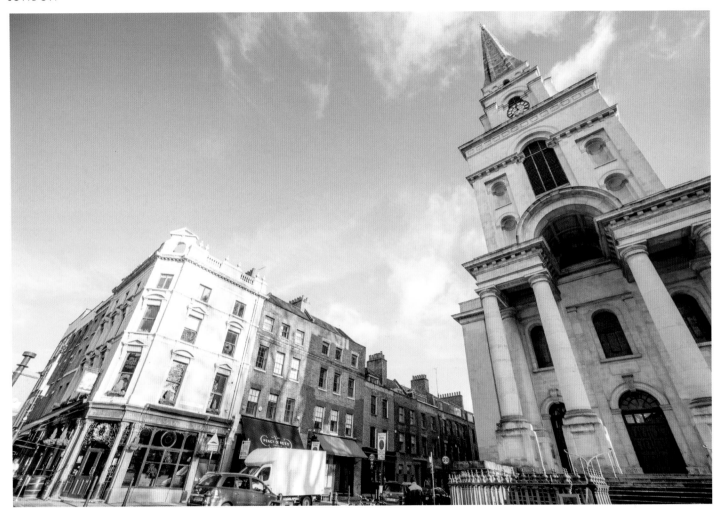

One of London's greatest architects was Nicholas Hawksmoor, a master of English baroque who designed six churches across the capital, including Christ Church (built 1714–1729) in Spitalfields. Next to the imposing church is the Ten Bells pub, notorious for its connection to the Jack the Ripper murders.

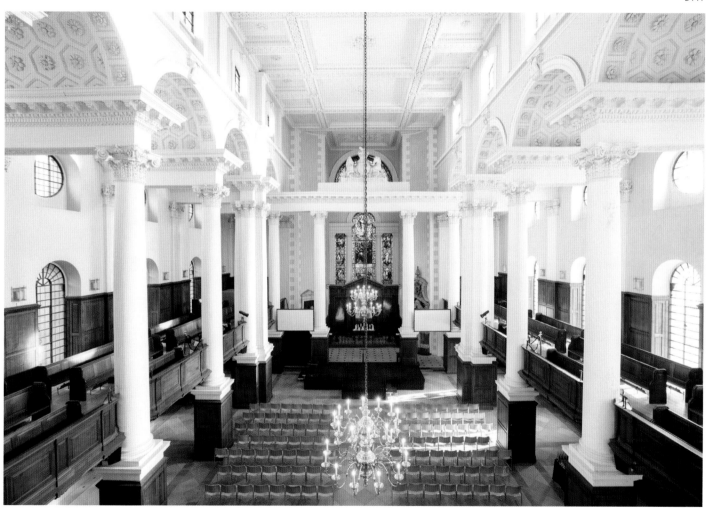

The restoration of the church by Andrew 'Red' Mason, completed in 2004, took ten years longer than its construction but returned the building to its pre-1850 glory. Hawksmoor's interior, half the volume of St Paul's Cathedral, is vast for a parish church. Its light-filled space is awe-inspiring (surely the intention).

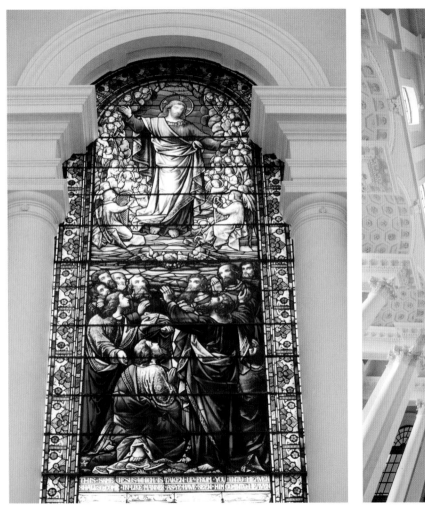

The Victorian stained glass windows were added in the 19th century; it is thought that Hawksmoor intended the windows to be clear for bright light. The organ, made by Richard Bridge, is original and, with more than 2000 pipes, was England's largest for more than a century.

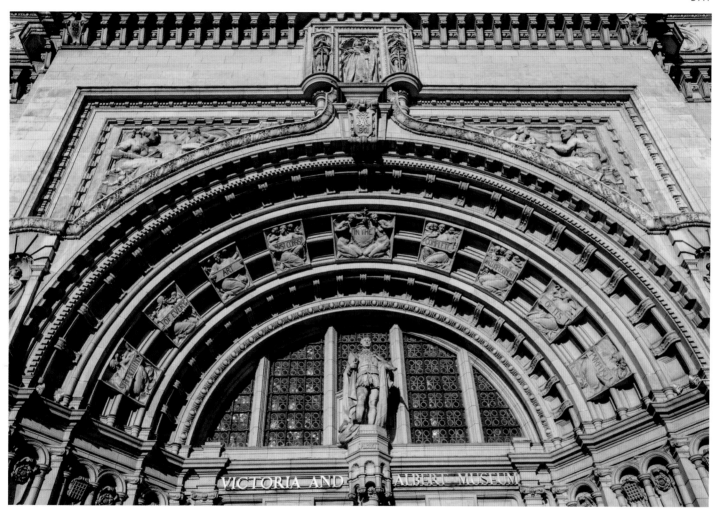

1300: London's most cultured public museum started life as the Museum of Manufactures, a spin-off from the Great Exhibition of 1851, which hopped around the city before making its home in South Kensington. Among other innovations, the Victoria & Albert Museum was the first museum in the world with its own refreshment room.

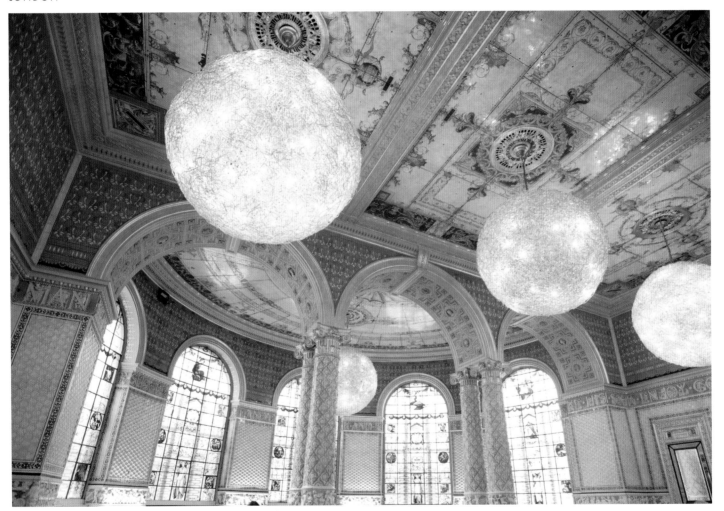

The V&A Refreshment Rooms are worth a visit as much for the architecture as for the menu. The three themed dining rooms, created by painter Edward Poynter, majolica-enthusiast James Gamble, and Arts & Crafts pioneer William Morris, once served three different menus, divided by social class.

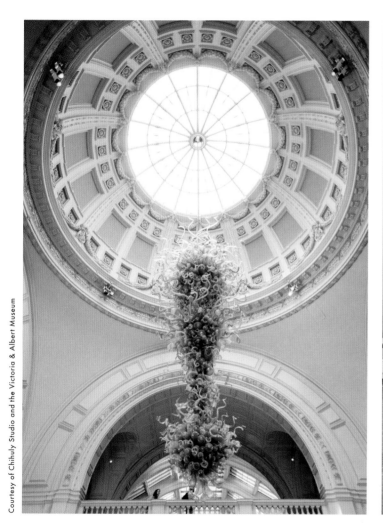

Known for creating unexpected experiences in unlikely places, American artist Dale Chihuly completed the V&A's landmark 27-ft tall chandelier in 2001.

Education was a personal passion of the museum's first director, Henry Cole, who filled the collection with casts of great treasures he couldn't acquire originals of.

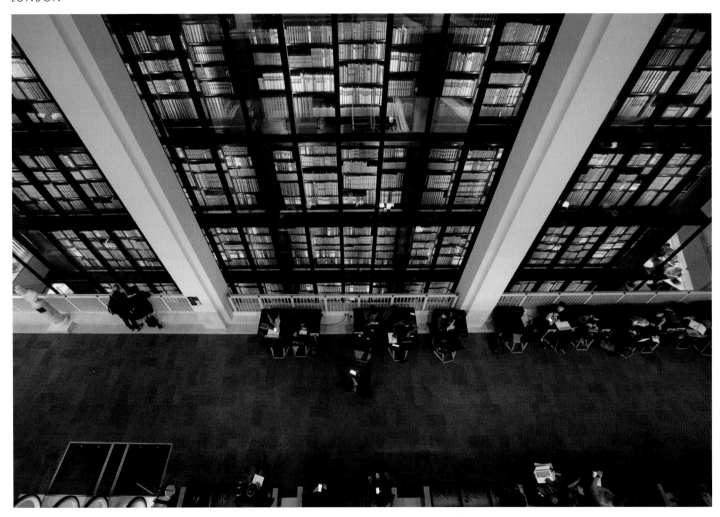

The British Library is another great repository of knowledge in London. It receives a copy of every book printed in the UK and its collection now includes more than 150 million items, including the Diamond Sutra, the world's oldest printed book, the Magna Carta and Leonardo da Vinci's Notebook.

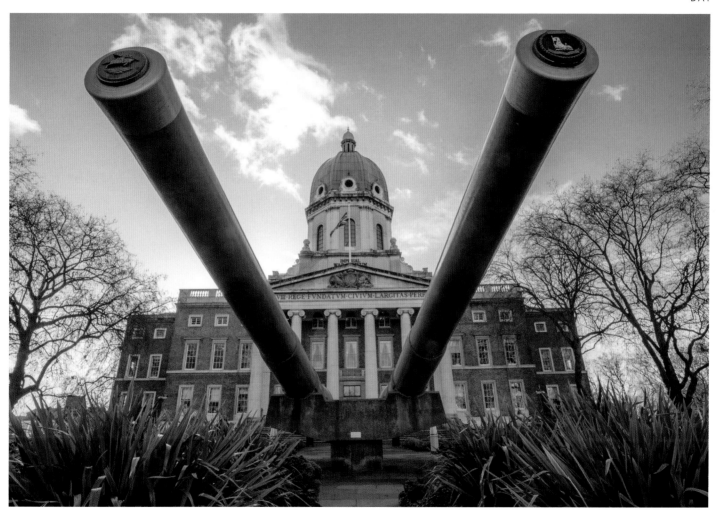

The Imperial War Museum is a reminder that conflict is an ever-present part of the human condition. At the museum's south London home a Spitfire and a Harrier jet are suspended in Foster + Partner's atrium but there are also permanent exhibitions on the Holocaust, the work of espionage, and also heroism.

'I remember back in 1999 I photographed Stephen Gough (the 'Naked Rambler') outside the Natural History Museum and was amused when he walked past the Exhibition Rd street sign making a great ironic frame for a newspaper. It's one of three major national museums on a single street no longer than a few hundred metres and named after the Great Exhibition of 1851. My most recent visit was to see the flying blue-whale skeleton which is proudly suspended in its new Hintze Hall home. The female blue whale named Hope replaces the much-loved Dippy the Diplodocus that was exhibited in the hall from the late 1970s. Dippy is now touring the length of the UK and amazing audiences just like the Naked Rambler did at the turn of the last century.'

- *Mark Chilvers*

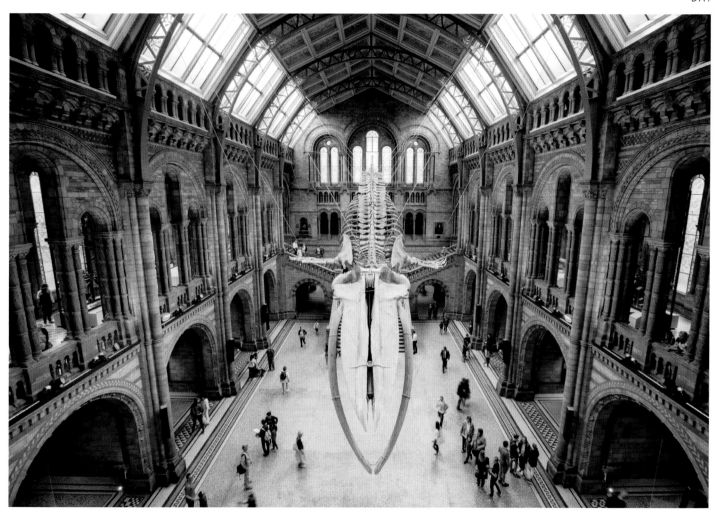

For most of its history, the Natural History Museum's grand Hintze Hall was graced by Dippy, the museum's famous diplodocus. In fact, the skeleton was a cast, and in 2017, the ersatz dinosaur was replaced by Hope, the genuine skeleton of a blue whale that washed ashore in Ireland in 1891.

Favourite hangout of tourists, goths and aging rockers insisting against all the evidence that Punk's Not Dead, Camden is the top spot in London to buy skull-shaped navel piercings, buckle-covered platform boots and Kanye West shades. Think of it as a kind of cosplay in which you're both participant and spectator.

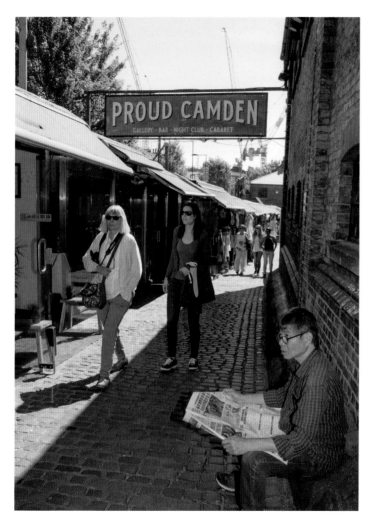

Proud Camden is set in the former Horse Hospital, founded to care for the 700 working horses once employed in the Camden Goods Depot.

Camden Market grew up around the disused storage depots and stables of Camden Lock, used by traders to move goods along London's canals.

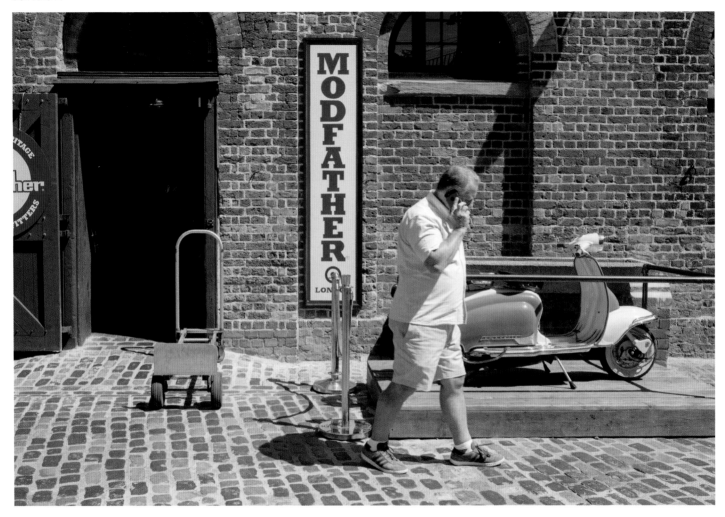

Punk was just one of many music scenes to grip Camden across the decades. Local clubs were favourite venues for the bands of both the original Mod scene and the 1980s Mod revival, and the Dublin Castle was centre stage for the 2 Tone ska movement, after Madness debuted there in 1979.

The London Underground covers an impressive 250 miles (402km), spread over a warren of tunnels beneath the city streets. During WWII, stations such as Hampstead, buried 192ft (58.5m) into Hampstead Hill, served a vital purpose as air-raid shelters for Blitz-bombarded Londoners.

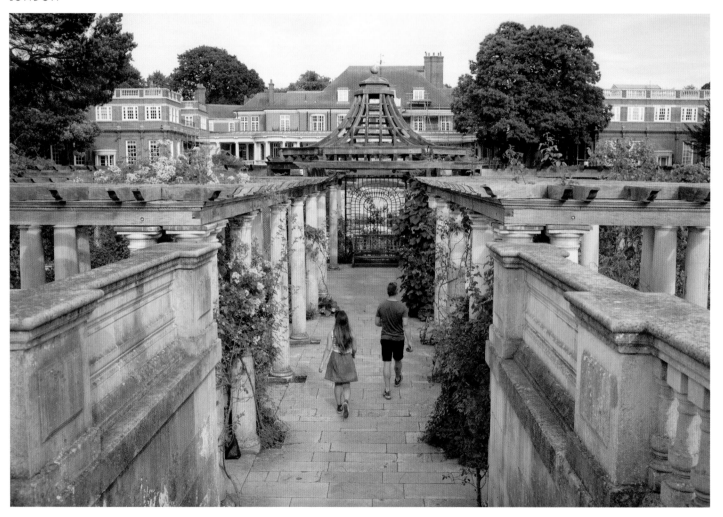

1400: Londoners rave about their city as much for its hidden corners as its cultural institutions. Tucked away on the side of Hampstead Heath, the delightfully dilapidated Pergola and Hill Gardens were constructed by eccentric soap mogul Lord Leverhulme, using earth excavated from the Northern Line Tube tunnels.

'Although new to me, the pergola in Hampstead Heath is a favourite with local artists. The walkways are apparently as long as Canary Wharf is tall and in summer the wooden frames are covered in wisteria. I wandered among couples taking quiet romantic walks, and a handful of fellow photographers staging low-key photoshoots around the slightly crumbling walls. It was a truly captivating spot, unknown to most people and visited by even fewer.'

- *Mark Chilvers*

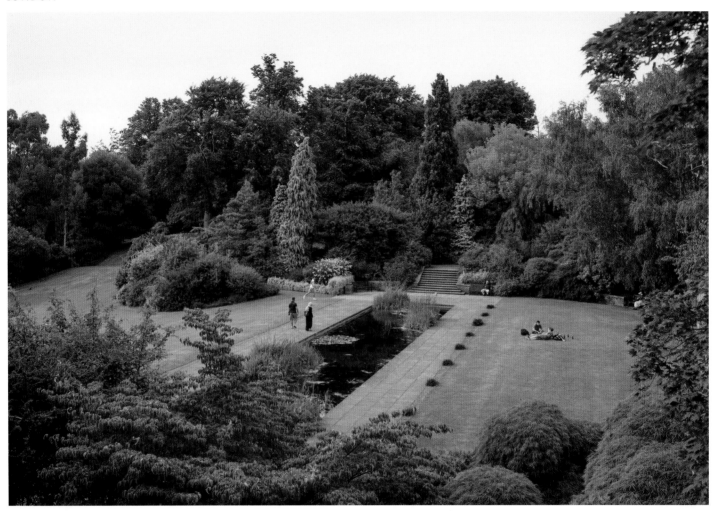

To construct the Hill Garden, Lord Leverhulme first needed a hill to raise the gardens to the appropriate height. In an age before mechanical earthmovers, the soil removed from the tunnels for the Northern Line was brought here by a legion of contractors using horse-drawn and hand-pulled carts.

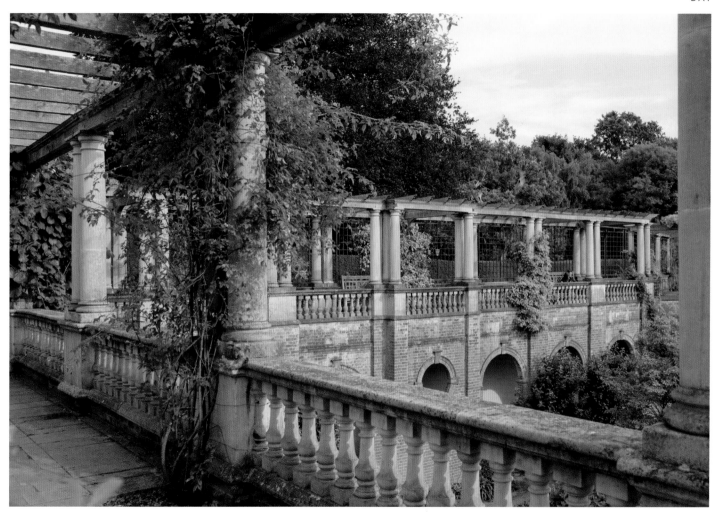

After the death of its owner, the Pergola fell into decline. The parties ended, and the sprawling wings of Leverhulme's grand house, The Hill, became a convalescence home for patients from Manor House Hospital. But it's still easy to imagine debutantes and suitors playing coy games along the Pergola's covered colonnades.

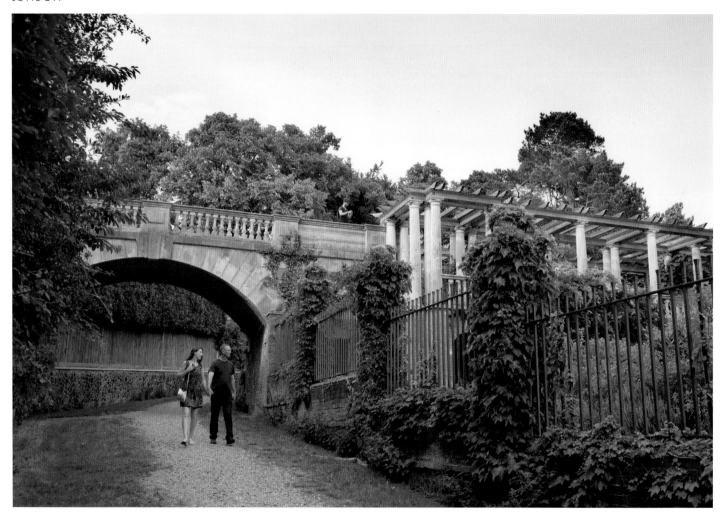

The Pergola and Hill Gardens were built in three phases, as Lord Leverhulme persuaded neighbours to part with land for his grand private playground. The problem of a public right of way through it was solved by a Portland-stone bridge, which allowed passersby to peek into, but not enter, his extravagant garden.

Hampstead Heath has always attracted eccentrics, so Lord Leverhulme was in good company. The home of John Keats lies just metres from Hampstead Tube, and Sigmund Freud's is a few blocks east on Maresfield Gardens. More recent Hampsteadites include George Michael, Stephen Fry and Michael Palin.

Despite its palatial properties, Primrose Hill has a reputation as a bohemian retreat for authors, actors and rock stars. There's even a resident sect of druids, the Loose Association of Druids of Primrose Hill, who celebrate the summer solstice every year at a small memorial to Iolo Morganwg, champion of the Welsh druidical revival.

Both Primrose Hill and Parliament Hill attract a daily tide of sunset watchers, who gather on dry evenings to see the sun going down over London's rooftops. Park attendants face a constant battle to keep the summits clear from beer-bottle tops left by sightseers who enjoy a tipple with their scenic panoramas.

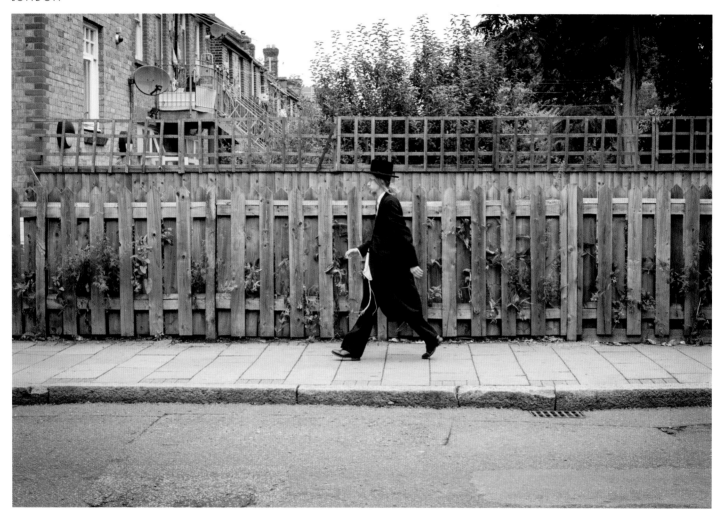

London is a city of migrants, and whole neighbourhoods can be mapped to the communities who set up shop here across the centuries. Northeast London's Stamford Hill is home ground for London's deeply traditional Haredim, conservative Jews who fled from Eastern Europe in waves from the 1880s to the 1930s.

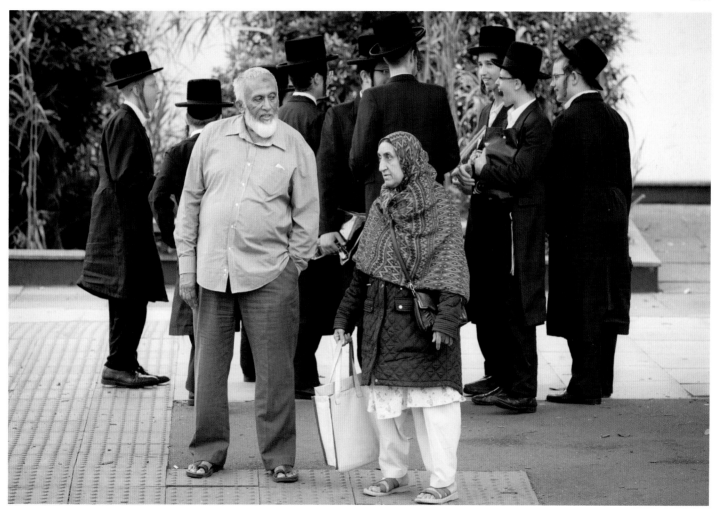

Stamford Hill's Hasidic community are strictly observant, rigorously following the traditions of the Torah, including the wearing of traditional clothing and not using electrical appliances on the Sabbath. Sub-sects of the Haredim can be identified by hats ranging from simple black fedoras to grand, fur-trimmed shtreimel.

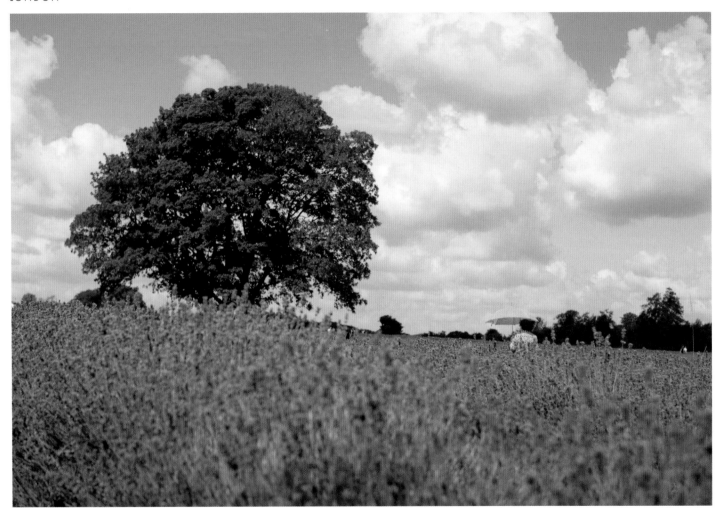

The outskirts of London extend ever outwards, consuming farms and villages and turning them into suburbs. The Mayfield Lavender farm presents a scene more common in the sun-kissed hills of Provence – endless rows of purple shrubbery – enclosed by the sprawl of suburban Croydon.

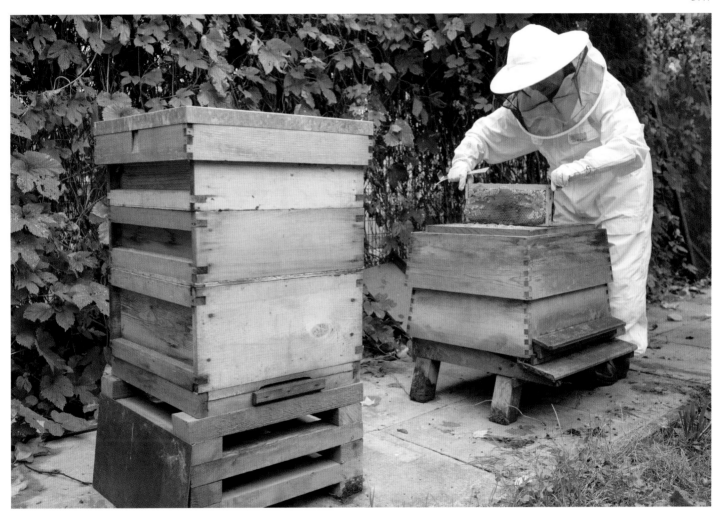

Despite the urban chaos, London is one of the world's greenest cities, with 47% of its area covered by parks and gardens. All this greenery creates fertile feeding grounds for bees, such as the honey bees raised by volunteer beekeepers in rooftop apiaries and pockets of unused ground around Lambeth and other boroughs.

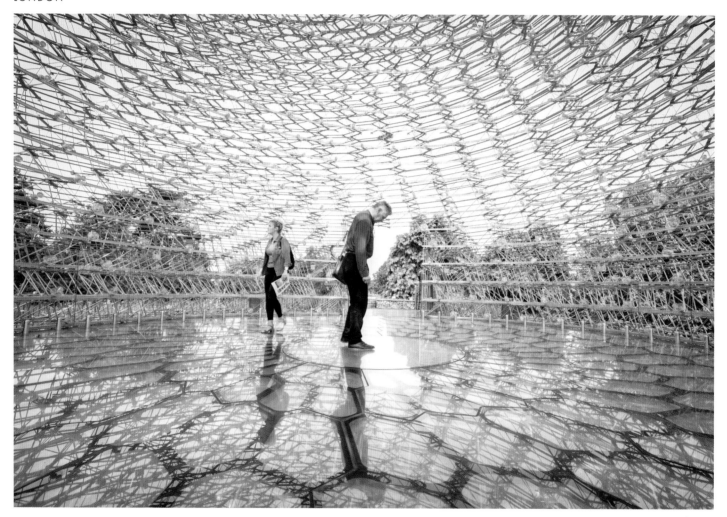

1600: The multilayered hexagons of the immersive Hive installation at Kew Gardens mirror the natural shape of beehives, and wild bees buzz through the structure from the surrounding wildflower meadows. The sound and light displays inside the structure are triggered by bee activity in a real beehive at Kew.

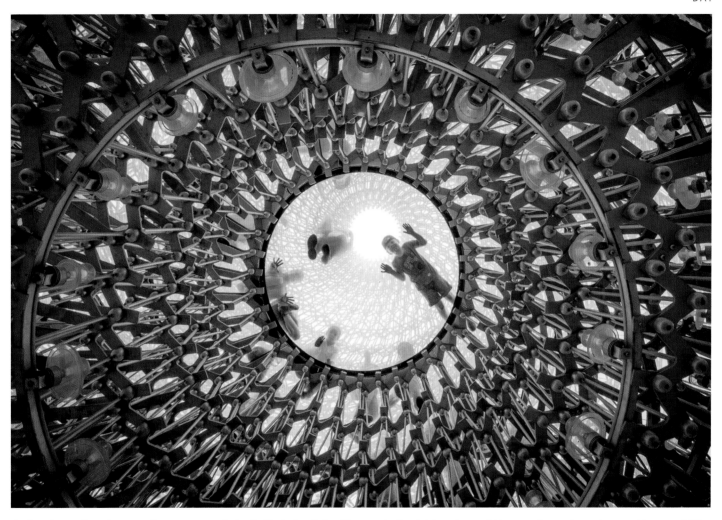

The bee-theme of Kew's Hive sculpture was intended to highlight the plight of bees in the British Isles, where wild bee populations have plummeted by up to 30% due to habitat change and exposure to modern pesticides. Kew's living collections depend on wild pollinators such as bees, butterflies, beetles, moths and bats.

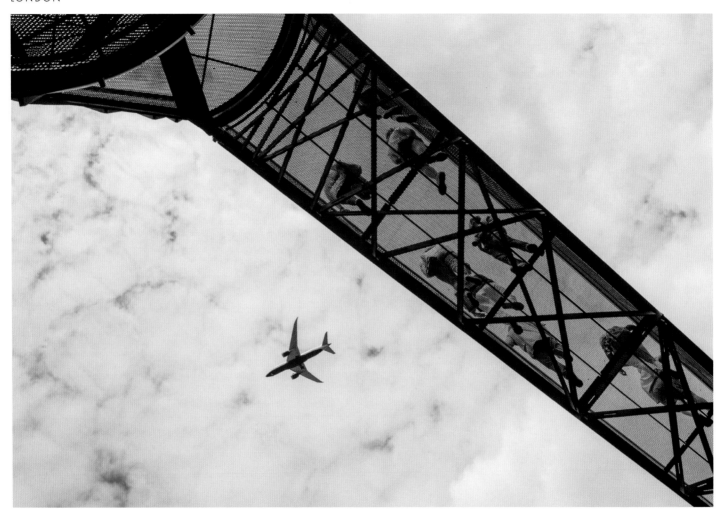

Plane spotters love Kew almost as much as naturalists, thanks to its position on the final approach to Heathrow Airport. Easily identifiable jets pass just a few hundred metres overhead, and the views looking down onto the gardens from above are just as impressive.

Kew preserves some of the largest plants on the planet and some of the smallest. As well as cactuses in every imaginable shape and size, Kew houses examples of the world's largest and smallest waterlilies, and a coastal redwood tree that has grown 129ft (39.3m) since it was planted in 1860.

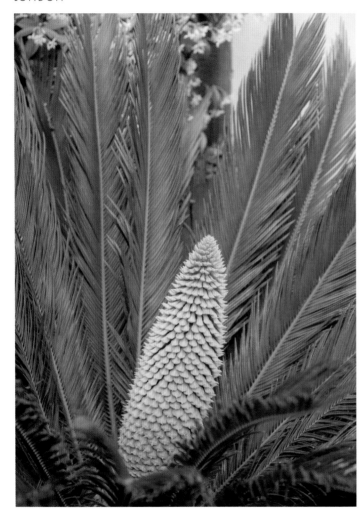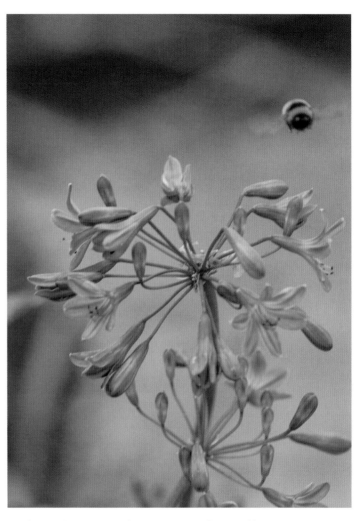

Kew has some of the rarest plants on Earth, including perhaps the rarest of all, the dwarf waterlily Nymphaea Thermarum, grown from seed here in 2009. An example of the exceptional lily was stolen from the Princes of Wales Conservatory in 2014, with blame falling on an as yet unknown rare plant collector.

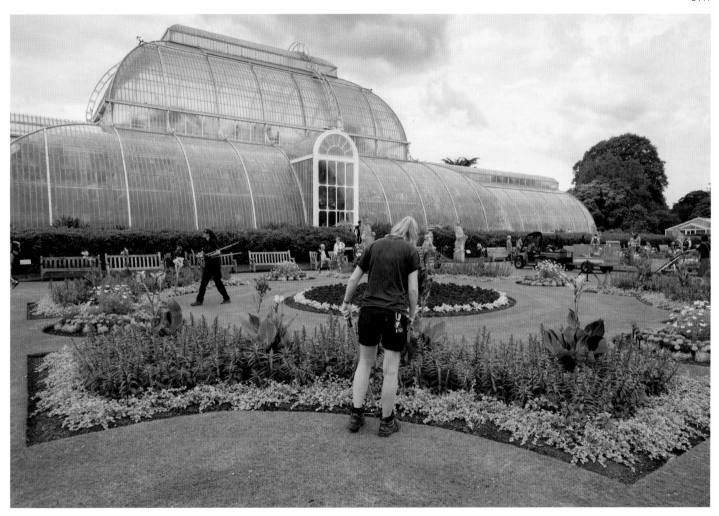

The elegant Victorian greenhouses at Kew are more than just ornamental. During the fevered years of European colonialism, naturalists propagated exotic species such as cinchona (source of the malaria treatment Quinine), allowing the establishment of new plantations that broke the monopolies of rival powers.

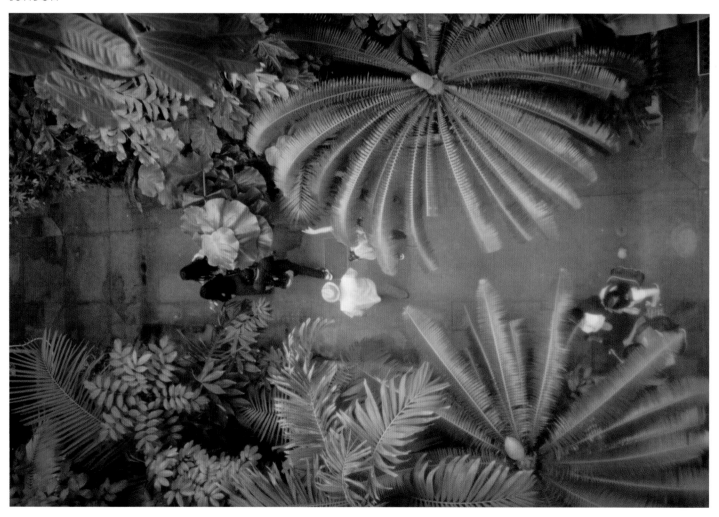

Visitors walking through the Palm House are shaded by the fronds of dozens of different species the tree, but topping them all is a venerable Jurassic cycad, the world's oldest pot plant, collected by botanist Francis Masson in the 1770s. Despite its 14ft-wide (4.4m) trunk, the monster palm is repotted every 20 years.

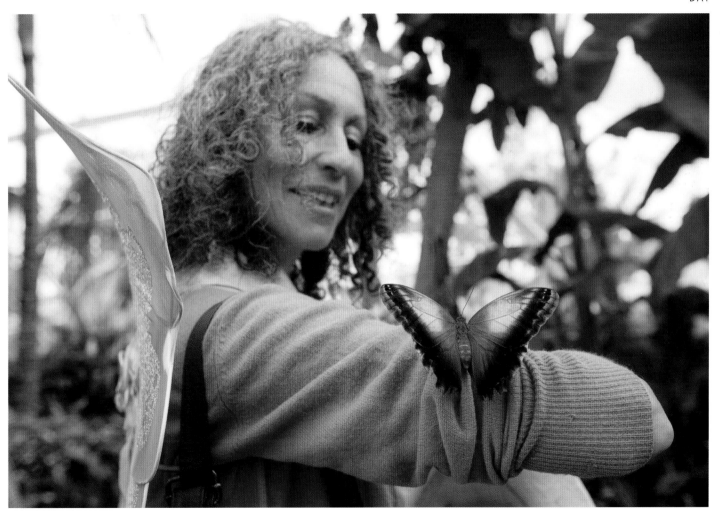

Blossoms are just one source of colour at the Hampton Court Palace Flower Show, held at the grand palace of the oft-married monarch Henry VIII. Free-flying monarchs of a different kind and lots of other exotic butterflies are a regular addition to the show, filling a geodesic dome set amid the flower gardens.

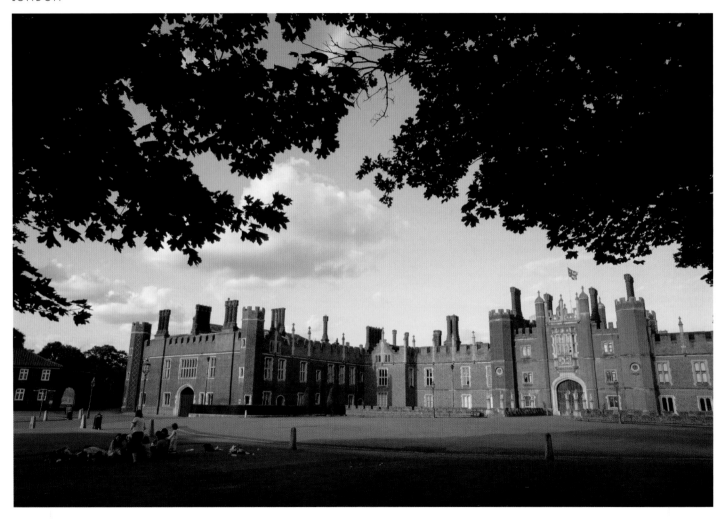

Hampton Court was the official address of the British monarch until George III eschewed Richmond for the central location of Buckingham Palace. He did, however, engage the services of Lancelot 'Capability' Brown – who went on to become Britain's most famous garden designer – to preserve the palace's ornamental gardens.

The world's largest flower show fills Hampton Court with blooms and 140,000 visitors every July, but it's a very recent arrival. Management consultant Adrian Boyd came up the with idea of the flower show to boost the profile of Hampton Court and the British railways, both suffering dwindling finances in the recession-hit 1980s.

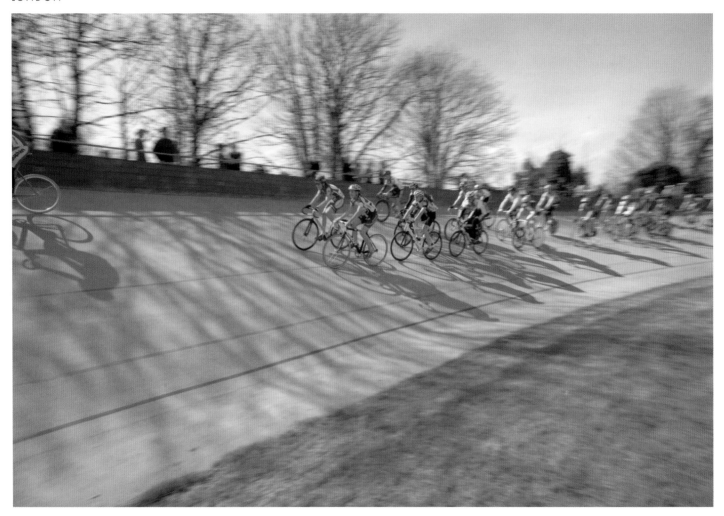

One of the world's oldest cycling tracks, the Herne Hill Velodrome was founded in 1891 by George Hiller, an amateur racer and secretary of the London County Cycling and Athletic Club, one of the world's oldest cycling clubs. Racing was carried out on the newly invented 'safety bicycle' with novel rear-wheel drive.

'Herne Hill Velodrome was centre-stage for the track cycling events during the 1948 Olympics and, in some ways, not that much has changed. However, the new clubhouse and access for disabled riders and children two-years upwards show that the venue is moving with the times. Their motto is 'run by cyclists, for cyclists', and this community spirit was evident when I visited with my camera and took my young son for a kids' cycle session.'

- Mark Chilvers

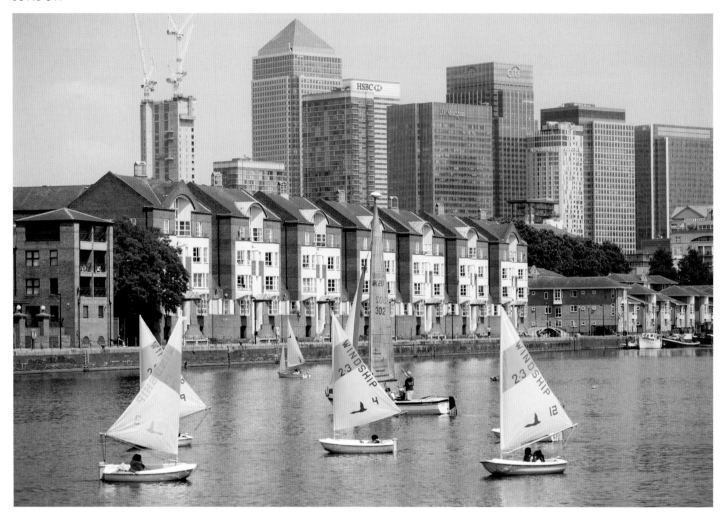

The Isle of Dogs was a thriving port from the 18th century until the arrival of containerisation and the closure of successive docks through the 1970s. Before redevelopment filled the area with office towers, the docks were so rundown that Stanley Kubrick used them as a stand-in for war-torn Vietnam in *Full Metal Jacket*.

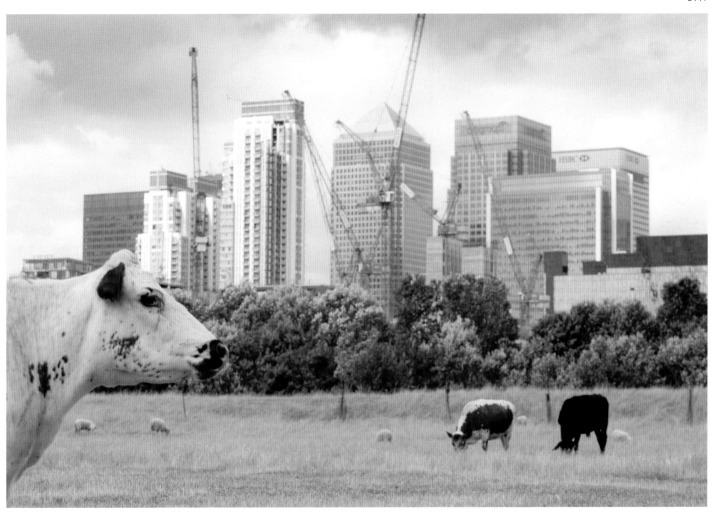

Just yards from Canary Wharf's skyscrapers, Mudchute City Farm stands as a monument to the community spirit of Docklands. In the 1970s, local residents blocked development plans for a treasured patch of overgrown land, in the process founding a farm that provides work and training for children from deprived backgrounds.

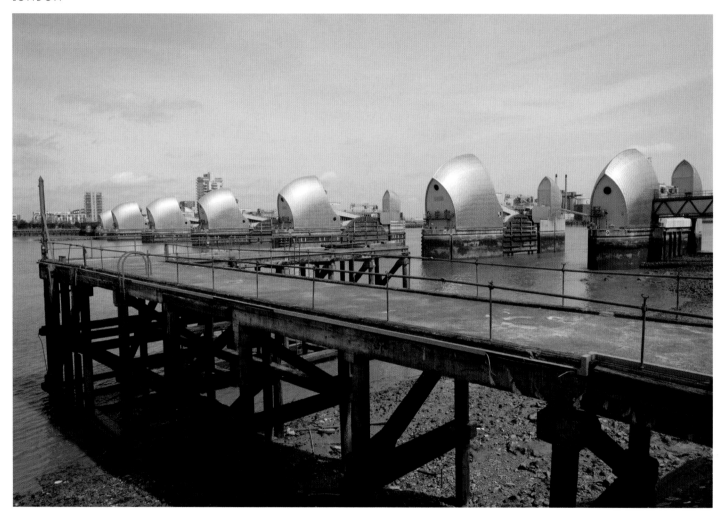

When The Clash wrote 'London Calling', the drowning they had in mind was a nuclear disaster, but London faces a very real risk of flooding because of the tidal nature of the Thames. The Thames Barrier was built in 1984 to regulate the waters, preventing high tides and storm surges sweeping upriver into inhabited areas.

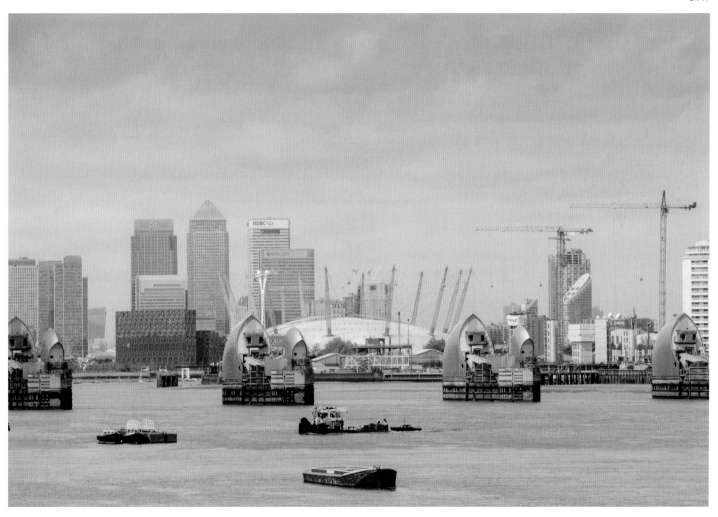

In an era of white elephants, the Millennium Dome stood out as a classic case of political grandstanding in the face of better advice from the experts. Built at huge expense to mark the millennium, it was filled with a string of underwhelming attractions that failed to excite, before finding a more useful purpose as the O2 Arena.

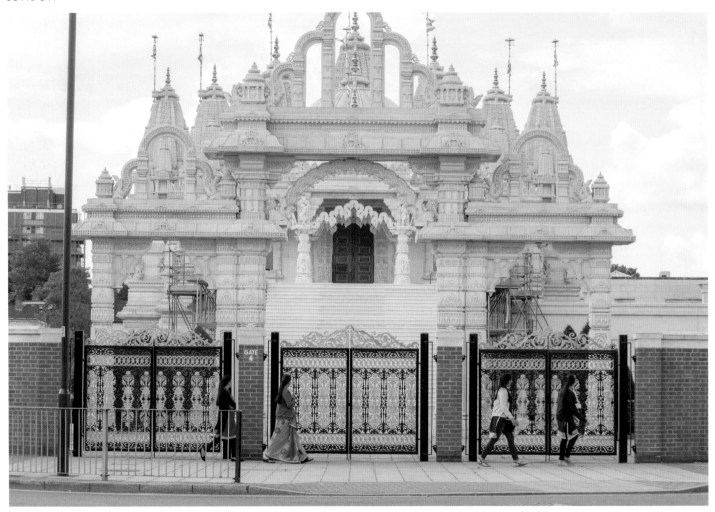

Built in the north Indian shikhara style, the Shri Swaminarayan Mandir in Neasden was the first purpose-built stone Hindu temple in Europe. The brainchild of a 92-year-old holy man, the temple was crafted by a team of 1526 sculptors in India, before being shipped in pieces to London and assembled in the suburb.

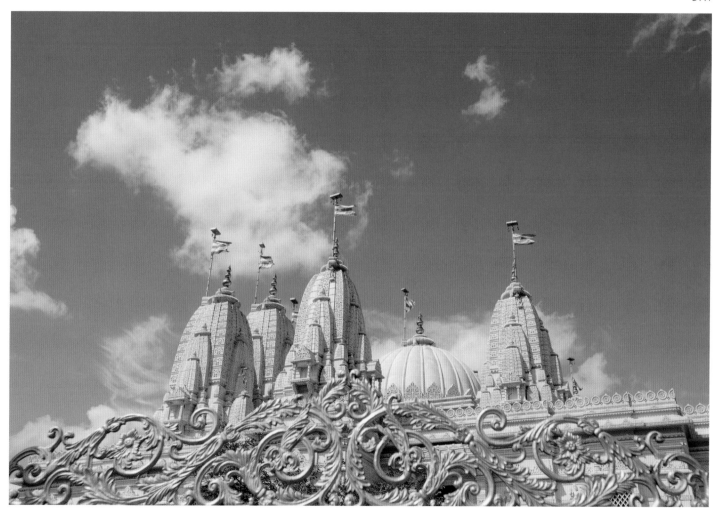

The ornate towers and domes of the Shri Swaminarayan Mandir are constructed according to the same architectural principles as ancient Indian temples. The superstructure is made entirely from stone, supported by cantilevering, with no steel or lead used to hold the blocks together.

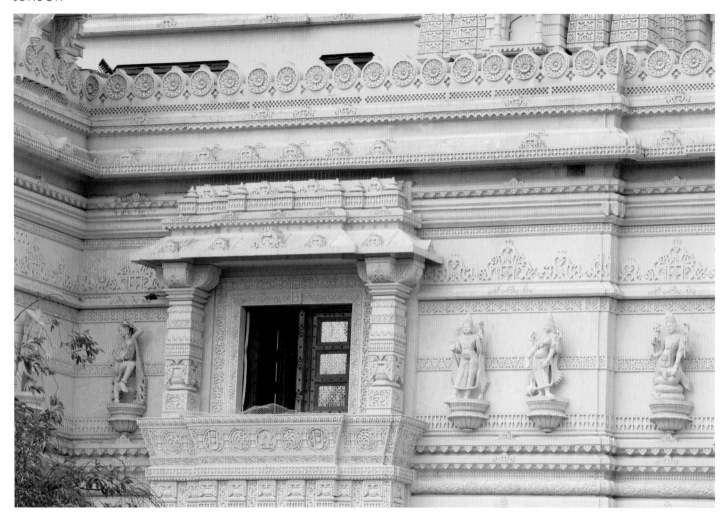

The Neasden Temple was funded by British Indians, at a cost of more than £12 million. Much of the bill was accounted for by 5000 tonnes of Bulgarian limestone and Italian Carrara marble. The ornate stone carving was carried out in Kandla in Gujarat, with 26,000+ pieces of cut stone shipped to London for assembly.

'Guests are welcomed at the temple but on my unannounced visit I was greeted by a large sign with some clear rules of entry, concerning dress code, smoking, chewing gum and seating arrangements. And there is a rule that no photography is allowed inside, but rather 'postcards are available in the gift shop'. So instead I observed with a sense of awe the beautiful carved limestone from the London street. The spirituality and contemplation of this temple can be felt beyond the gilded gates with their board of rules that keep photographers and guide dogs at a polite distance.'

- *Mark Chilvers*

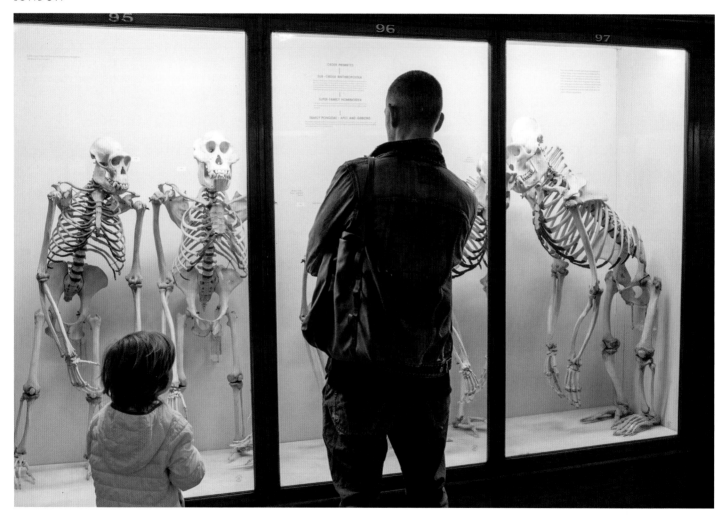

Housed in a landmark Arts and Crafts building, the Horniman Museum has a collection to rival many central London museums. The tea mogul Frederick John Horniman personally amassed more than 30,000 ethnographic objects, from a stuffed Canadian walrus to ornate metal plates that once graced the royal palace of Benin.

Founded in 1890, Dulwich Park was one of a series of grand Victorian parks created by the Metropolitan Board of Works, the municipal department charged with providing infrastructure for London's exploding population. The Board became notorious for corruption, earning it the nickname 'Metropolitan Board of Perks'.

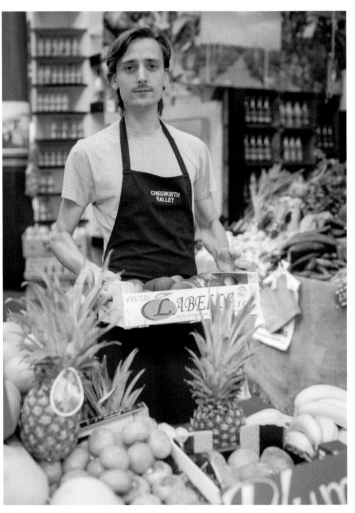

The Brexit vote on EU membership sparked a frenzied discussion on the future of the British-grown produce at London's foodie playground, Borough Market. Millions of seasonal workers from Poland, Romania and Bulgaria, including Jonasz from Chegworth Valley, work on UK farms, picking, packing and selling fruit and veg.

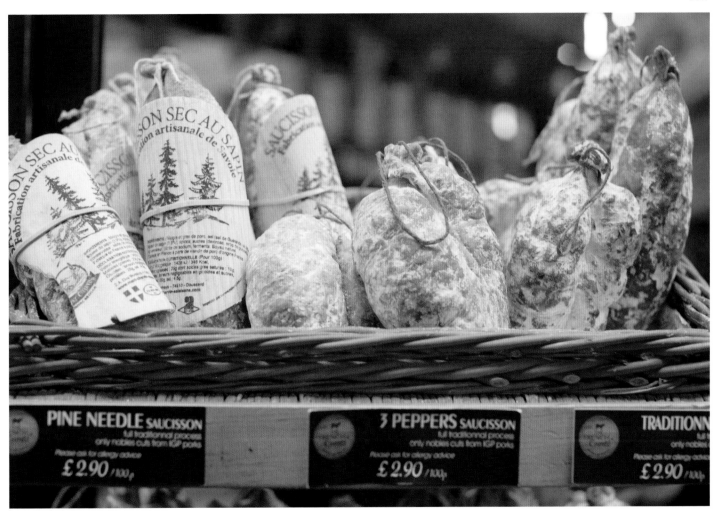

Borough Market has a pedigree which vastly predates its 20th-century rebirth as the place to buy quality culinary goods such as traditional French sausage. The original market straggled through the medieval streets south of London Bridge. Traders date its foundation to 1014, but the earliest written record is from 1276.

'Borough Market is close to where I had an office for several years but it has been a food market for 1000 years. I visited to photograph the market for this book the week after the London Bridge terrorist attack and was amazed at how the market had immediately and defiantly refilled with people, crowding the stalls and surrounding pubs. Seeing the market spring back after this senseless and random attack seemed to epitomise the essence of what London is: ever changing, but ever resilient, steeped in its long history but all about the individuals that make up the place today.'

- *Mark Chilvers*

By the 1970s, Borough Market was a shell of its former self, sucked dry by the growth of supermarket shopping. In 1998, new arrivals Neal's Yard Dairy and Tapas cafe Brindisa led to the three-day Food Lovers' Fair, which brought together about 50 of the best food producers in Britain. Borough has never looked back.

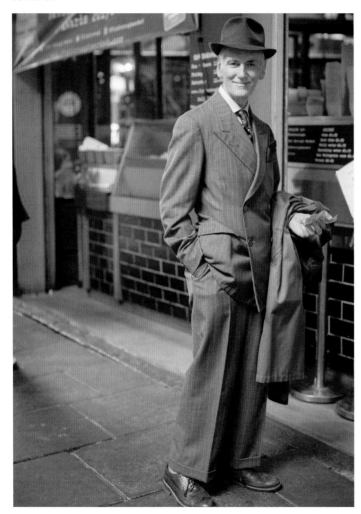

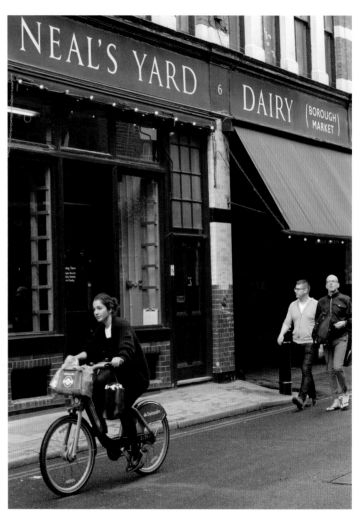

Londoners of all stripes frequent the market's stalls and surrounding restaurants, pubs and high-end fast-food outlets, many dishing up traditional British fare.

Initially a Covent Garden wholefood shop, Neal's Yard soon embraced baking, coffee, beauty products and cheese, spawning Borough's Neal's Yard Dairy.

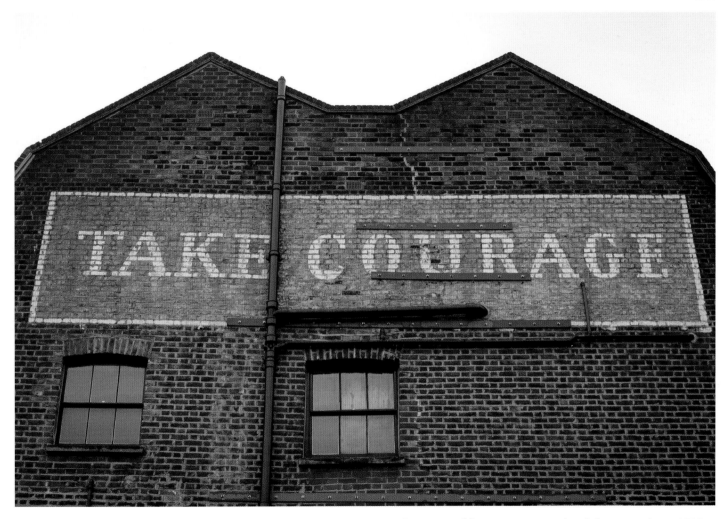

Fuller's dominated West London and Truman claimed the East End, but south London was the preserve of the Courage Brewery, founded in Bermondsey in 1787. Of French Huguenot descent, John Courage ran the brewery for just six years before dying at the age of 36, but the name of his ale has survived centuries.

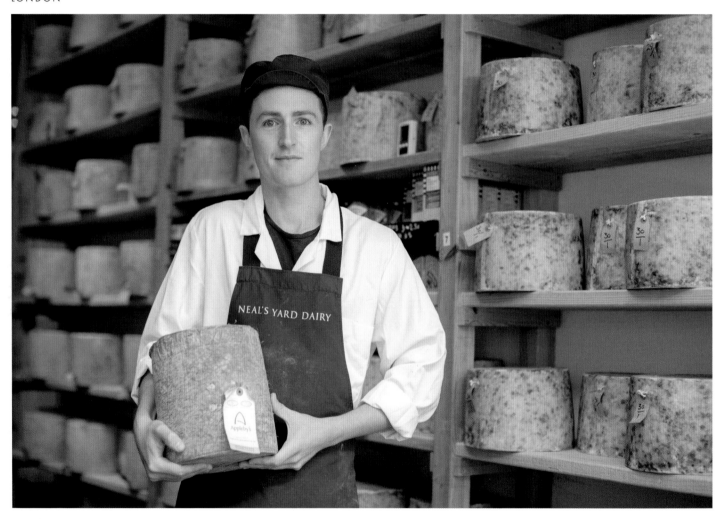

In the 1970s, the British cheese industry was sinking fast, with traditional cheesemakers struggling against factory-produced cheese sold at discount prices. Stinking Bishop was one of the artisanal cheeses to reverse the trend, produced in Gloucestershire with milk from the then dwindling, now growing Gloucester breed of cattle.

One of London's favourite weekend traditions is assembling a picnic from the globe-trotting ingredients on sale at Borough Market: hand-cut wild boar salami, freshly baked sourdough, a slice of organic cheese here, a bottle of pale ale there... top spot to enjoy the feast is a South Bank bench, overlooking the Thames.

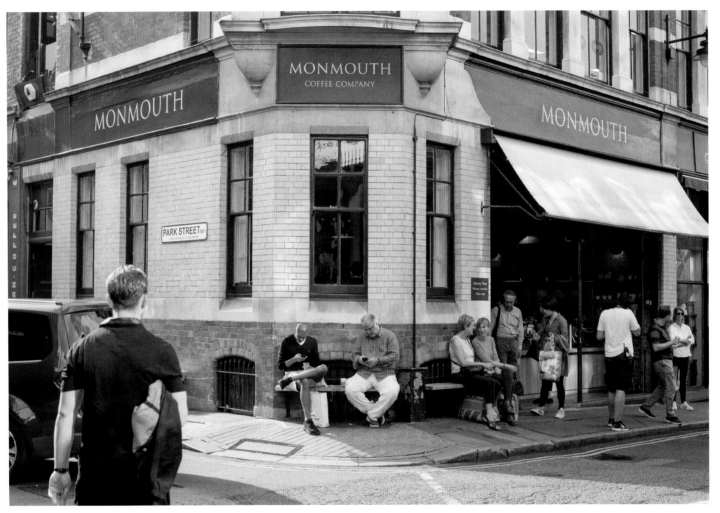

Monmouth Coffee House is another Borough Market success story. Roasting her own coffees and blends in 1978 in a small Covent Garden space, founder Anita Roy pioneered the notion of single-origin coffee in the UK, starting a kick-back against the ubiquitous high street coffee chains. It expanded to Borough in the 1990s.

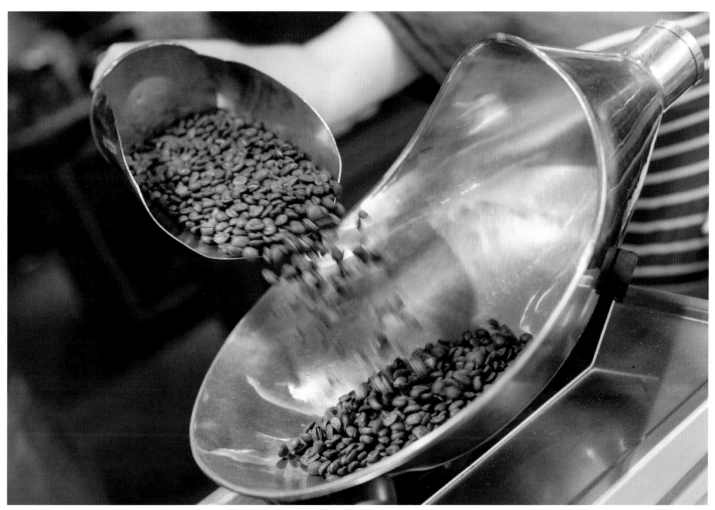

Coffee first reached London in 1652, when an immigré called Pasqua Roseé started selling the native brews of Smyrna (now Izmir, Turkey) in St Michael's Alley, Cornhill. Another revolution took place in the 1950s, when Italian baristas introduced London to the aromatic joys of espresso.

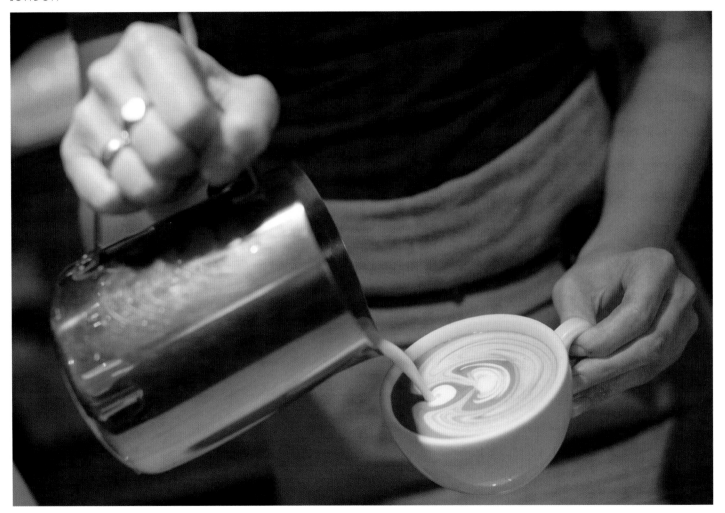

Though traditionally a tea-drinking nation, coffee has now truly percolated the UK consciousness. Londoners are addicted to their morning cup and Monmouth Coffee Company is just one of an ever-growing list of top-notch, small batch microroasters in the capital that are willing to handle the supply.

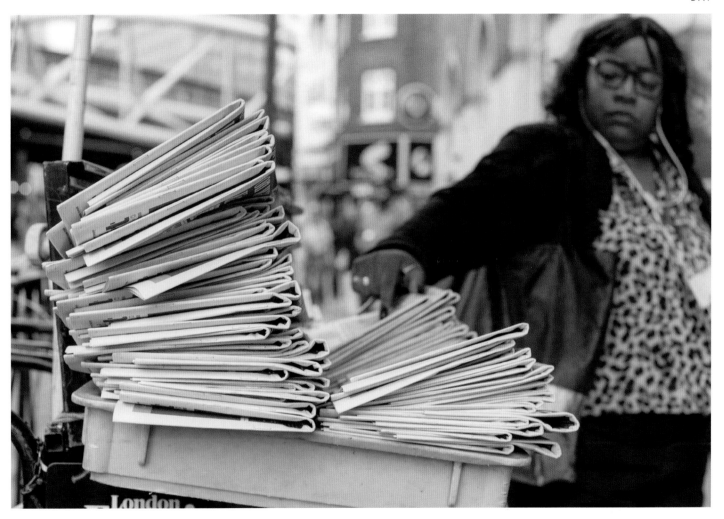

1800: When London's first free newspaper launched in 2006, it started a news revolution. *London Lite* (now defunct) was soon joined by *Metro, The Evening Standard* and several other clones and wannabes. Passengers on the Tube now dispose of a staggering 9.5 tonnes of free newspapers every day.

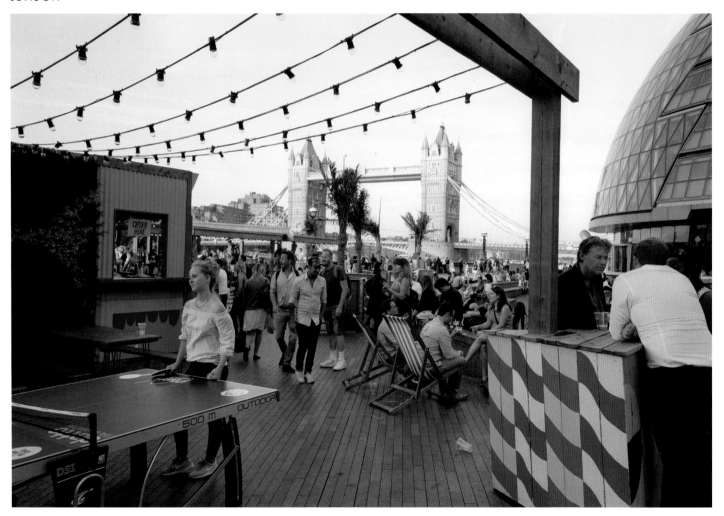

Described variously as a misshapen egg, a woodlouse, and Darth Vader's helmet, London's modernist City Hall is the headquarters of the Greater London Authority and the Mayor of London. The unconventional shape is actually a concession to energy efficiency, reducing the exterior surface area exposed to sunlight.

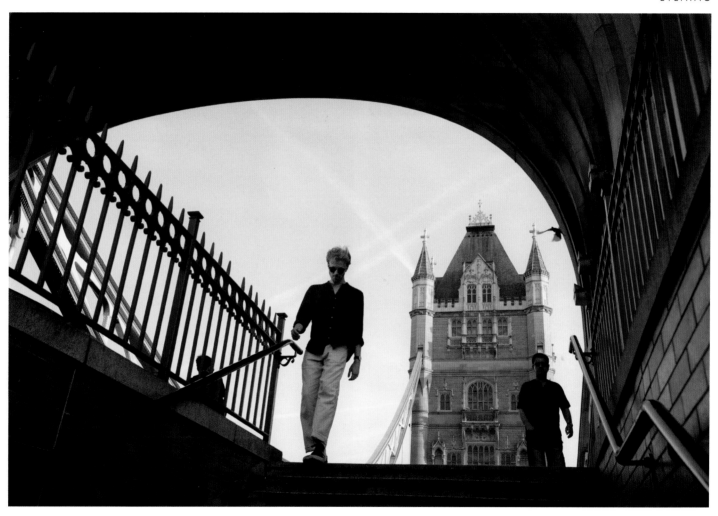

As afternoon draws to a close, office workers cross London's bridges bound for the capital's commuter hubs. Tower Bridge is the city's last bridge that tall ships can pass under; the mechanism to raise it was once powered by hydraulic pumps, but today electric motors lift the bridge on the 1000 or so times it opens every year.

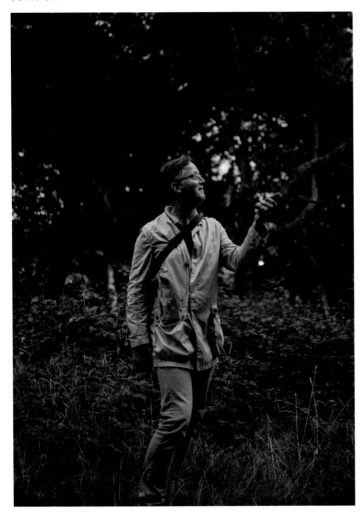

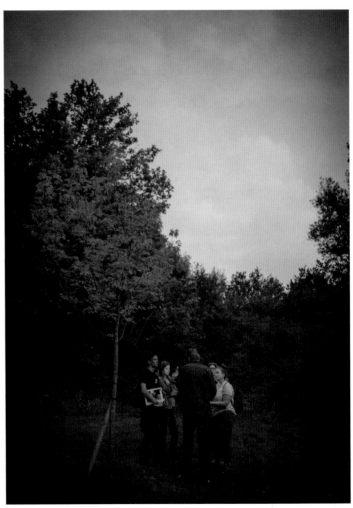

1900: The London Bat Conservation Trust and London Bat Group stage sorties into the nighttime gloom with high-tech scanners, in search of the elusive bats.

Although eight species of bats live in the city, the population has dropped by more than 38% since the 1980s due to a decline in insect prey.

'Meeting up with a group of strangers in a church car park on the edge of a wood as darkness fell had all the hallmarks of a *Blair Witch*-style horror film. However the handheld echo-location detectors reassured me that we were just out to listen to and hopefully see some nocturnal bat action. Unfortunately my camera shutter confused the hand-held devices and in the time that I followed this group of bat hunters I only saw one dark shadow of a bat race across the night sky.'

- *Mark Chilvers*

'As I was leaving the Brixton Ritzy having photographed a staff portrait and mingled with the cinema-goers enjoying drinks at the bar, I spotted Matt with his white-rimmed glasses and pencil-thin moustache. I had to ask if I could take his picture. It was no real surprise when he told me he was an actor; he looked as if he had walked straight off the silver screen and graciously allowed me to shoot a few frames as he sipped from his glass of beer, looking like a star in his own movie.'

- Mark Chilvers

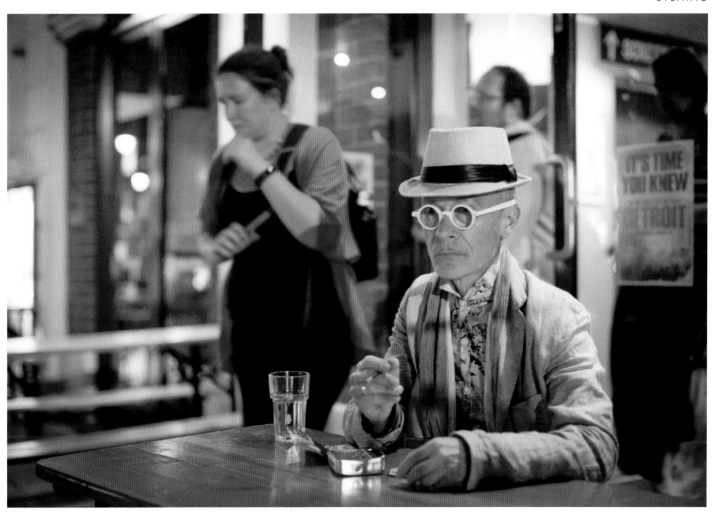

Despite the rise of the multiplex, London's independent cinemas are going from strength to strength. As night falls, film buffs gather at venerable independent filmhouses such as Brixton's Ritzy, which first opened its doors in 1911 as the Electric Pavilion, complete with a live organ player to accompany silent movies.

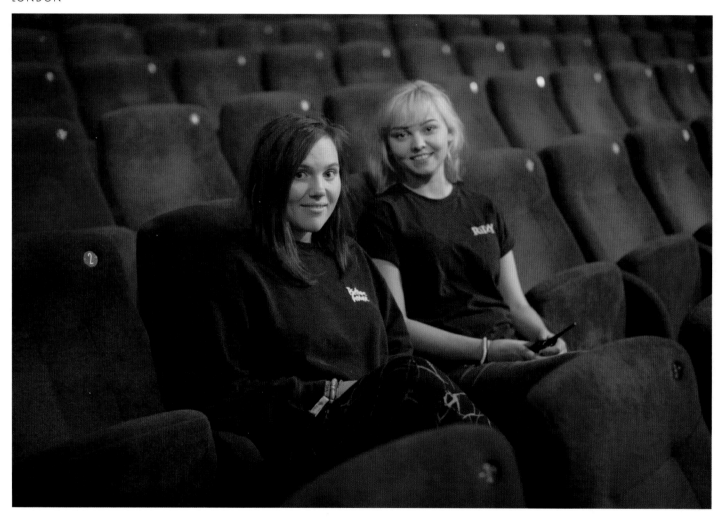

The Ritzy has a reputation for alternative cinema – so much so that it once ran a newspaper ad assuring would-be patrons that it also screened films that weren't left-wing or gay. The staff and clientele exude a firmly alternative vibe, as you'd expect from fans of subtitled cinema and board games (played in the upstairs bar).

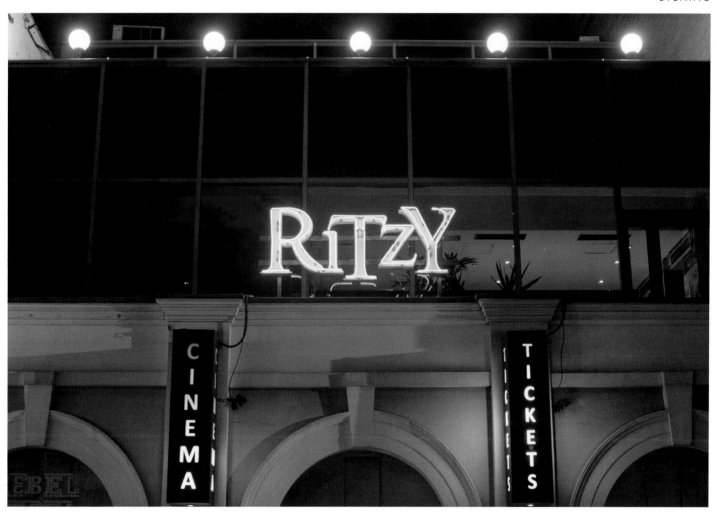

A Brixton landmark, the Ritzy's independent programme and vibe has been maintained by its current owner, the Picturehouse mini-chain (itself operated by Cineworld). Picturehouse runs nine cinemas across London, from Clapham in the south to Crouch End in the north, Notting Hill in the west to Stratford in the east.

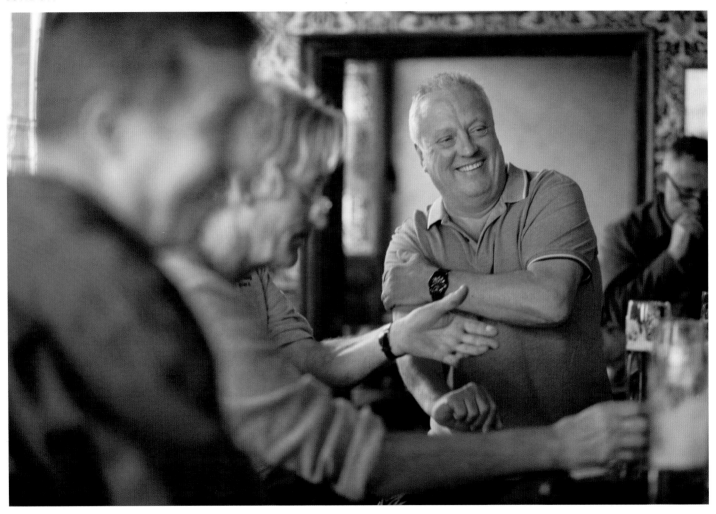

Putting the world to rights is a British male tradition, conducted over pints of bitter or lager, with the full knowledge that the topic under discussion will be no further advanced by the end of the conversation. Keep an ear to the ground in London's pubs and you'll hear locals discussing everything from power tools to Nietzsche.

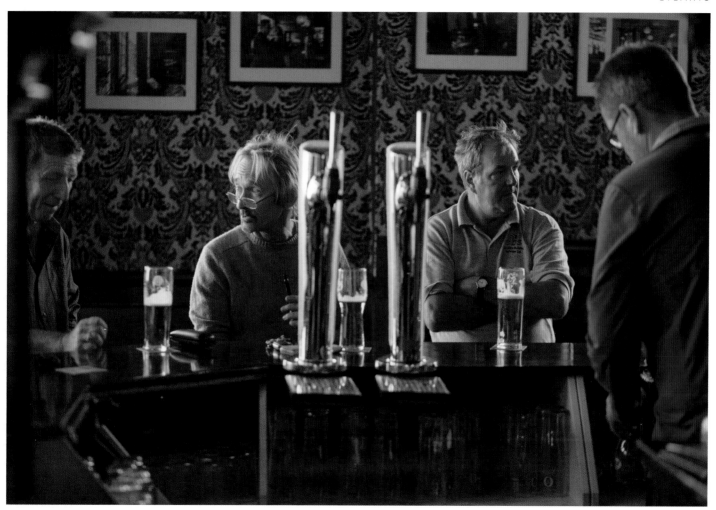

2000: London's Victorian pubs hark back to a more innocent time, when a public house graced every street corner and social drinking was the backbone of male working life. The ideal old man's pub should have plenty of seating, an absence of loud music, and no olives, chorizo or hummus. Pickled eggs are OK.

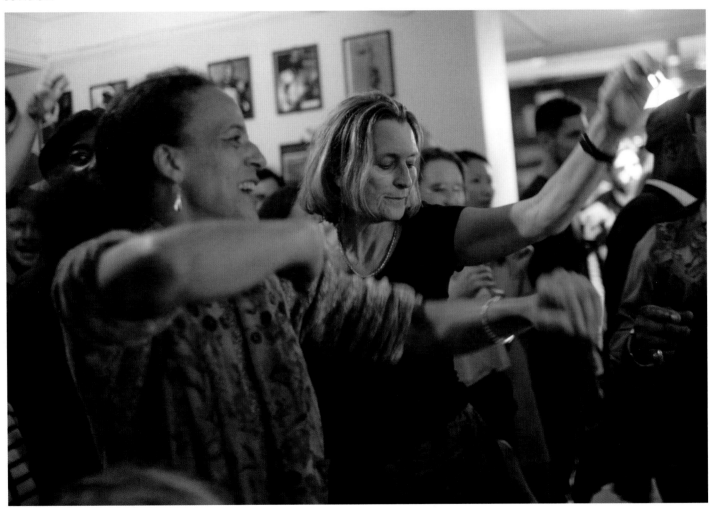

Brixton's watering holes are going upmarket, swapping Red Stripe for craft ale and wooden chairs for distressed sofas. Not so the Effra. The free Thursday, Saturday and Sunday jazz and reggae sessions pull local talent and an audience that spans the generations from Jamaican grandmas to youthful trendies.

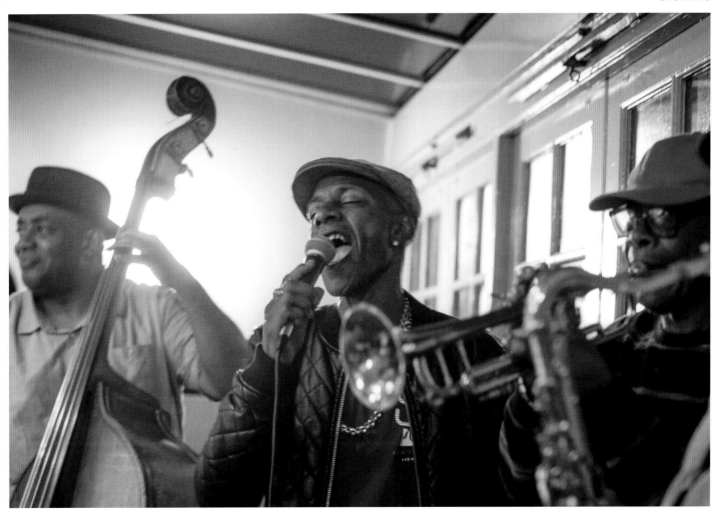

2100: Among the line up of performers at the Effra's legendary jazz open-mic Sundays, you may spot such veterans as UB40 trumpeter Patrick Anthony leading the house band. As the all-singing, all-dancing compere, jazz-blues singer Lauren Dalrymple has been filling the venue with soul for more than two decades.

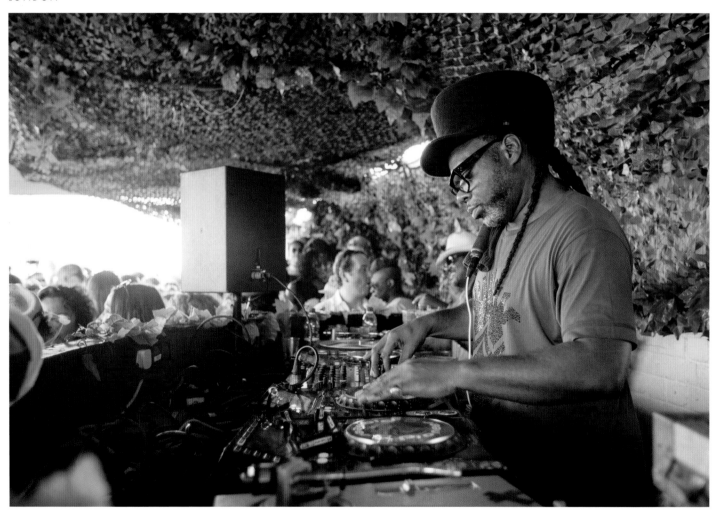

London's music scene offers rich listening for fans of vintage vibes. Veterans including R&B pioneer Jazzie B (of Soul II Soul fame) still play regular sets at venues such as Brixton's Prince of Wales, filling dancefloors decades after topping the charts.

Black music in London has a history of pushing the envelope, setting a lead followed by the rest of the world. Rap and hip hop became mainstream in London before they were accepted by mainstream America, and grime sounds are filtering back across the Atlantic, inspiring Stateside DJs with London trends.

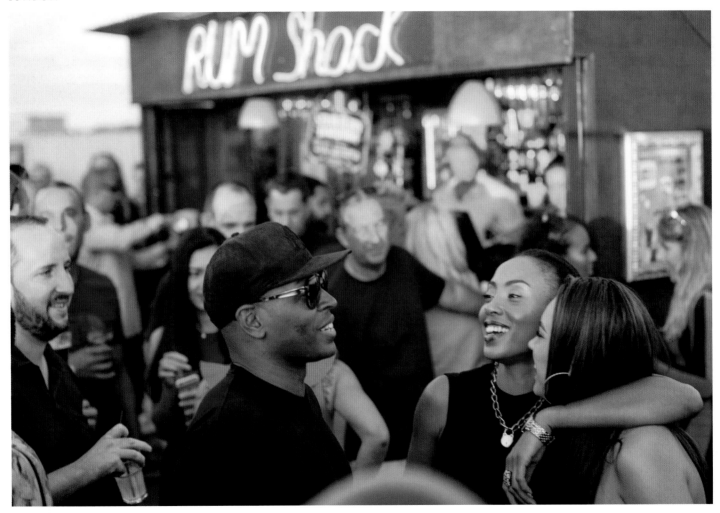

Many London music scenes grew out of the accidental segregation of socio-economical groups, but its bands and DJs have always blurred the lines. From big-band jazz to two-tone ska and 1980s soul to grime, nightlife in the city has always been a melting pot, mirroring London's varied social tapestry.

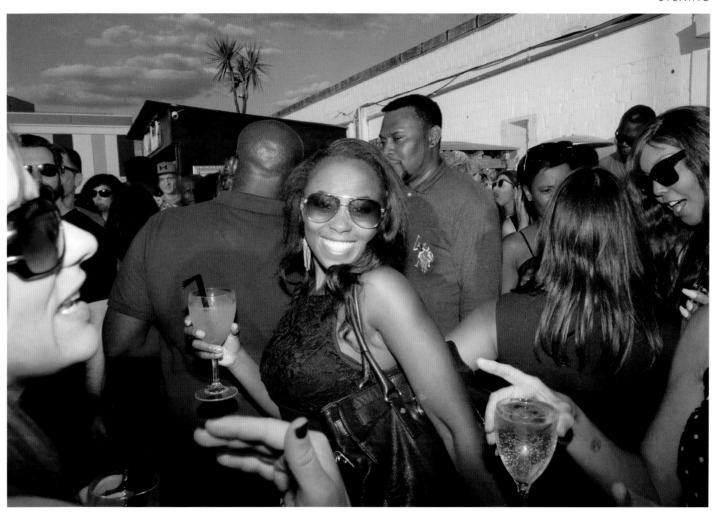

2200: London can't compete with the tropical climate of Kingston or Miami, but it does a convincing job of creating the open-air party vibe. Once-forlorn rooftop spaces atop car parks, office blocks and pubs are being rebooted as cocktail bars, craft-beer cafes and clubs, filling the summer skyline with bodies and basslines.

'Walking in through the doors of Hornsey Town Hall was like going back in time. I was warmly greeted by men and women in vintage period outfits while swing music drifted out from the wood-panelled dance hall. Men and women of various generations were spinning and whirling around to the soundtrack of 1930s vinyl swing, while others took a rest or waited to be invited to dance. As the records changed so did the dance partners; there was great energy that night and while I didn't attempt to swing dance I did feel quite envious of all the great suits and hats on display.'

- Mark Chilvers

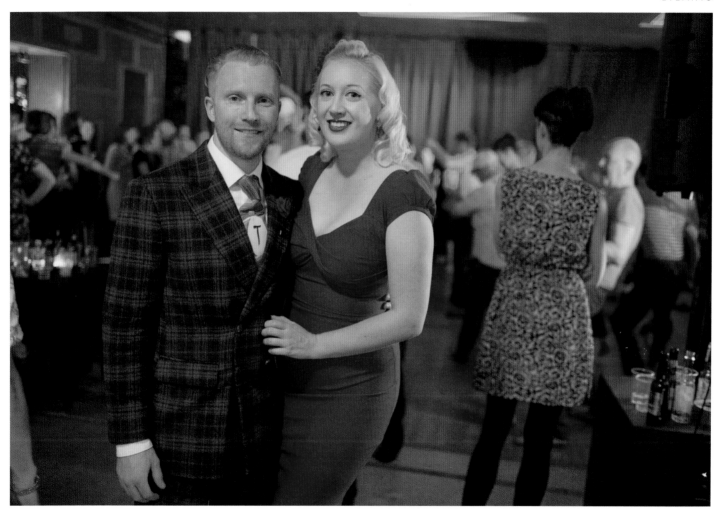

The growth of swing in London is partly a response to the logistical challenges of finding a like-minded significant other in a city of nine million people. If you have big-band jazz, interwar fashion and swing dancing in common, you're probably already a pretty good match.

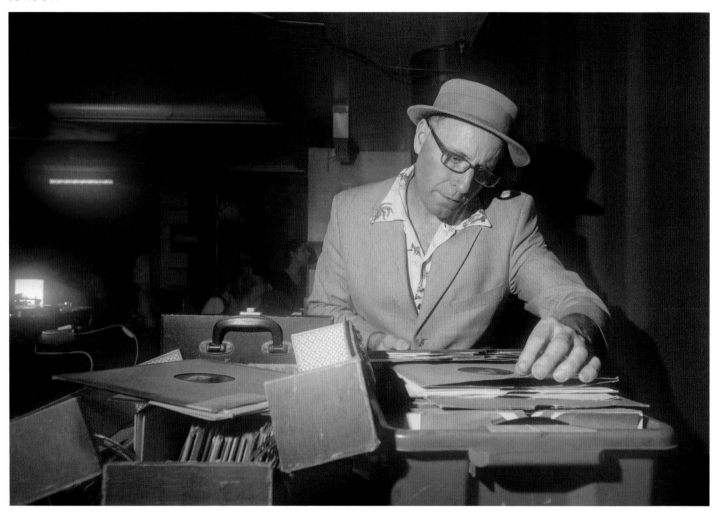

People are drawn to the swing scene for the music as much as the dancing. DJs such as Paul Golledge of Mouthful O'Jam tote crates full of original, pancake-thick vinyl 78s by the likes of Cab Calloway, played on original Art Deco turntables for the full hiss, crackle and jive experience.

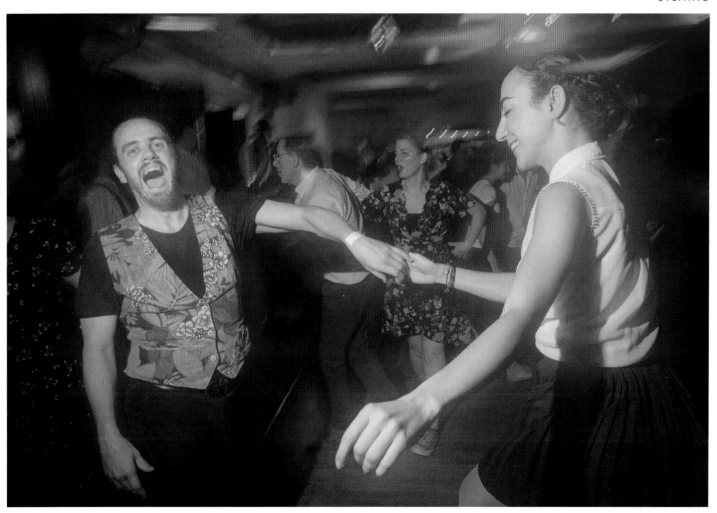

2300: Swing is another genre that crosses the age barrier. Dancefloors are dotted with pensioners who remember the tunes from their childhoods, and even the odd old-timer who danced to jive the first time around, alongside crowds of young, high-spirited dancers with the flexibility and moves to make the most of the occasion.

Published in May 2018 by Lonely Planet Global Limited
CRN 554153
www.lonelyplanet.com
ISBN 978 1 7870 1343 8
ISBN (US) 978 1 7870 1811 2
© Lonely Planet 2017
Printed in China
10 9 8 7 6 5 4 3 2 1

Publishing Director Piers Pickard
Associate Publisher & Commissioning Editor Robin Barton
Art Director Daniel Di Paolo
Photographer Mark Chilvers
Writer Joe Bindloss
Editors Yolanda Zappaterra, Nick Mee
Print Production Larissa Frost, Nigel Longuet
Thanks to Flora Macqueen

STAY IN TOUCH lonelyplanet.com/contact

AUSTRALIA The Malt Store, Level 3, 551 Swanston St,
Carlton, Victoria 3053 T: 03 8379 8000

IRELAND Digital Depot, Roe Lane (off Thomas St),
Digital Hub, Dublin 8, D08 TCV4

USA 124 Linden St, Oakland, CA 94607
T: 510 250 6400

UNITED KINGDOM 240 Blackfriars Rd, London SE1 8NW
T: 020 3771 5100

Although the authors and Lonely Planet have taken all reasonable care in preparing this book, we make no warranty about the accuracy or completeness of its content and, to the maximum extent permitted, disclaim all liability from its use.

Paper in this book is certified against the Forest Stewardship Council™ standards. FSC™ promotes environmentally responsible, socially beneficial and economically viable management of the world's forests.